IMAGES
of America

BETHLEHEM

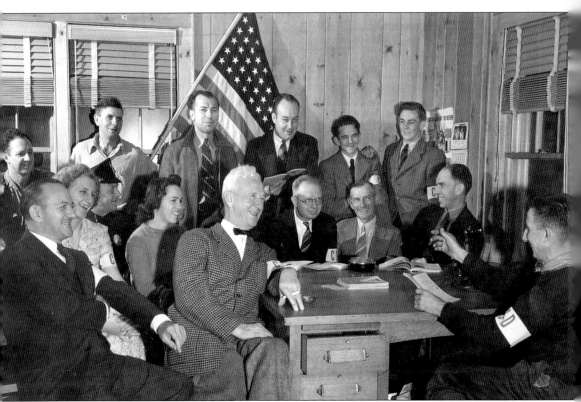

"Burras Traub presides with yankee wit over a meeting of air raid wardens at the town hall. This room is manned the clock around for defense activity calls." Pictured from left to right are (first row) William Smith, Dorothy Anderson, Thomas Bate, Virginia "Piff" Smith, John Gemmell, Henry Johnson, Kenneth Webster, Arthur Bloss, and Chief Warden Burras Traub; (second row) Dave Hart, Mark Kitchin, Bill Fadus, Paul Johnson, W. Reed Smith Jr., and Charles "Bud" Woodward. This image was originally published in the February 1943 issue of *Photo Story* magazine. (Photograph by Michael Levelle.)

On the cover: Please see above. (Photograph by Michael Levelle.)

IMAGES
of America

BETHLEHEM

Carol Ann Brown

ARCADIA
PUBLISHING

Published by Arcadia Publishing
Charleston SC, Chicago IL, Portsmouth NH, San Francisco CA

Printed in the United States of America

Library of Congress Control Number: 2008943465

For all general information contact Arcadia Publishing at:
Telephone 843-853-2070
Fax 843-853-0044
E-mail sales@arcadiapublishing.com
For customer service and orders:
Toll-Free 1-888-313-2665

Visit us on the Internet at www.arcadiapublishing.com

*I dedicate this book to Rena Waite, Arnold E. Smith,
Merton Hornbecker, and my grandmother Harriet Eels Duncan
of Milford, whose love of history and genealogy I have inherited.*

CONTENTS

ACKNOWLEDGMENTS

The Waterbury *Republican-American* newspaper (WRA) (William J. Pape II, publisher) has contributed to almost every Arcadia Publishing book in our area, including this one. Rena Waite was a tireless historian and recorder of town history at First Church of Bethlehem (FCB) and Old Bethlem Historical Society (OBHS) until her death in 1977. Merton Hornbecker of Woodbury restored over 200 archival photographs of Bethlehem. His negative collection forms the basis for this book. Arnold Smith was an early president, board member, Civil War buff, and Hornbecker's partner on the restoration of the society's archival photographs. Mother Jerome of the Abbey of Regina Laudis spent years meticulously compiling a history of the early families of Bethlehem. Jean Smith, Helen Woodward, and the late Dorothy Snowman were the collections committee for the Old Bethlem Historical Society for many years, laboring under unbearable conditions in the museum's attic. Barbara Plungis Shupenis, curator of the Lauren Ford Collection, has been responsible for recording the Lithuanian immigrants. Bethlehem native Vincent Bove, with a grant from Hewlett-Packard, scanned all of the photographs used in this book.

INTRODUCTION

To celebrate the country's bicentennial in 1976, a sign was placed by the town of Bethlehem, the Old Bethlem Historical Society, and the Connecticut Historical Commission in front of the new town office building, welcoming visitors to the small village. Quoted from the sign, the brief history that follows hopefully encourages the traveler to stop at one of the historic houses or to take a walk around the green.

The spring session of the 1703 General Assembly granted to the town of Woodbury the right to enlarge its bounds. Negotiations with the Indian inhabitants were successfully concluded and in 1710 a deed of sale, signed by Nunawague and five other chiefs, conveyed to Woodbury nearly eighteen thousand acres, known thereafter as the North Purchase. This included the present town of Bethlehem and parts of the later Judea, now Washington. Surveyed in 1723, and, after proprietors were granted their rights, divided into lots, it was opened for sale. Pioneers arrived in 1734, settling on the heights northeast of the present center. In 1738 young Joseph Bellamy was called to preach during "winter privileges." Separate "society privileges" were granted in October 1739. Bellamy was requested to continue as pastor, and so remained until his death in 1790, as the settlers established their own Bethlem Church and school. Doctor Bellamy became a most distinguished author, preacher and teacher, conducting the first theological school in American. Young men lived in the Bellamy home while he grounded them in his brand of scriptural interpretation and preaching methods. Among future leaders who studied there were Aaron Burr, Jonathan Edwards II, and James Morris. Bethlem men served in the French and Indian and subsequent wars. Numerous are the captains and lieutenants buried in the Old Cemetery. Bethlem was incorporated as a separate town in 1787. Mainly a farming community until the 1900's, it had sufficient water power for 18th Century industries—fulling mills, cotton mill, woolen mill, wagon factory, straw hat and bonnet factory and miscellaneous manufactories of leather goods.

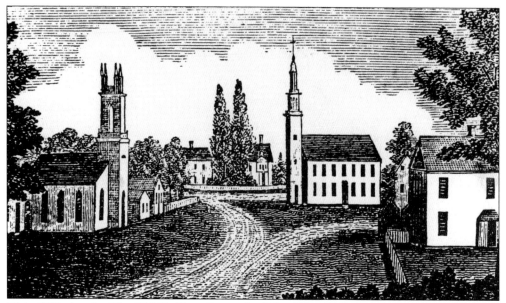

This 1835 sketch, *The Old Bethlem Green,* by John Warner Barber appeared in his book *Connecticut Historical Collections* in 1836. (*Connecticut Historical Collections.*)

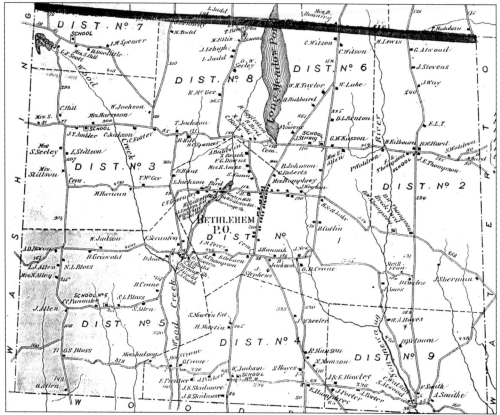

This 1874 map of Bethlehem from the *Atlas of Litchfield County,* 1874, shows the nine school districts. (*Atlas of Litchfield County.*)

8

One

EARLY HOMES

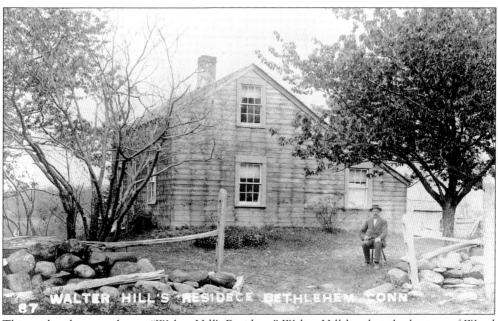

This undated postcard says, "Walter Hill's Residece." Walter Hill lived at the bottom of Wood Creek Road near the former farm of Shaker Assard. (Mary Woodward.)

The home of Rev. Joseph Bellamy was the site of the first theological school in the United States in 1754. He was one of the best-known orators of the Great Awakening led by Jonathan Edwards. No paintings or sketches of Bellamy exist, but he was said to stand six feet five inches and weigh over 300 pounds. In 1744, he purchased land north of the town green, and it became the site of his residence until his death in 1790. Note the cow grazing on the estate lawns on the left of this c. 1900 photograph. (OBHS.)

David Bellamy (1750–1825), son of Joseph Bellamy, lived in the house and worked as a farmer. (FCB.)

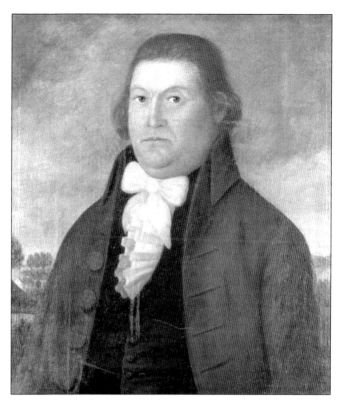

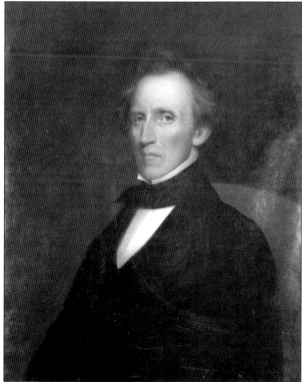

Joseph Hart Bellamy (1788–1848), a lawyer, was the only child of David Bellamy and the grandson of Joseph Bellamy. In 1892, Elizabeth Bellamy Loomis, Joseph Hart Bellamy's daughter, donated these paintings to the town of Bethlehem. (FCB.)

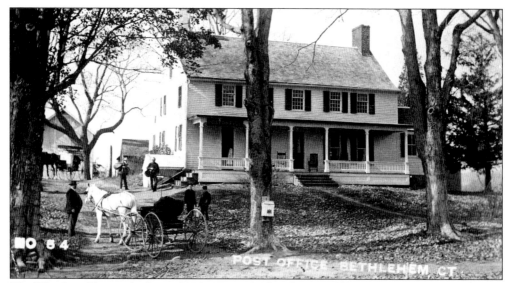

The Woodward house, built in 1740 by Samuel Church, once filled the role of a post office. In 1797, Betsy Church married David Bird and it became the Bird Tavern. According to Mary Woodward, the story goes that with a wide doorway, "horsemen would ride into the inn, draw up at the open bar and in loud voices order drinks, consume them without dismounting and ride into the courtyard and down the street." The house was a station on the Underground Railroad during the Civil War, and Joshua Bird was a conductor. Pictured in the photograph are postmaster James Flynn (far left) with mail carriers Ed Crane (left) and John Hollenbeck (right) in the background. (Mary Woodward.)

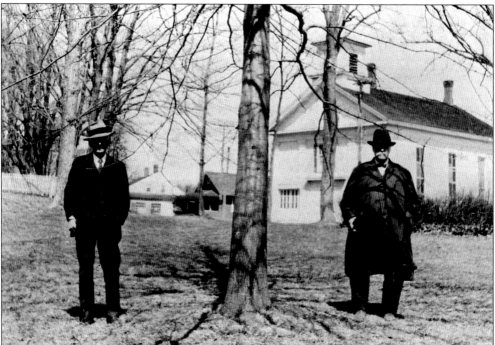

Edward N. Crane (left) and James W. Flynn are on the green next to the 1902 constitutional oak. (Mary Woodward.)

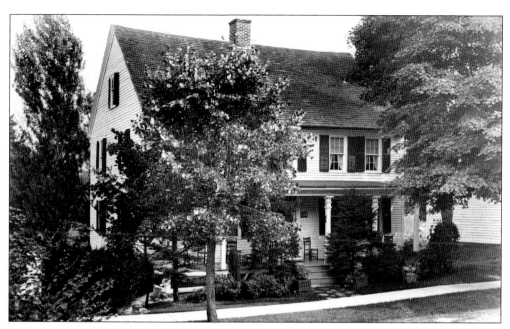

Originally on the southwest corner of the Bellamy property, this house was the home of Rev. Joseph Bellamy's successor Azel Backus, later the first president of Hamilton College. Backus is pictured at right. The house was then physically moved to the corner of East Street at 3 Main Street South. It was home to William Doolittle in the early 1900s and was called Doolicor (Doolittle's corner). A postcard proclaimed it "a beauty spot in the lower Berkshires . . . Altitude 1000 feet Sunrise Avenue and The Boulevard, Bethlehem, Conn . . . Once the residence and meeting place of eminent scholars and noted men. Used as a theological seminary by the early Congregationalists. Afterwards occupied as a Methodist parsonage." (WRA.)

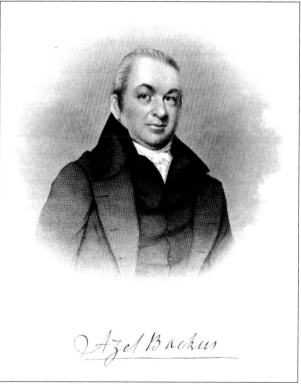

Mapledale at 64 East Street was the home of Albert and May Allen Johnson. Albert Johnson (left) ran for the Connecticut House of Representatives as the "farmer's candidate." (Mary Woodward.)

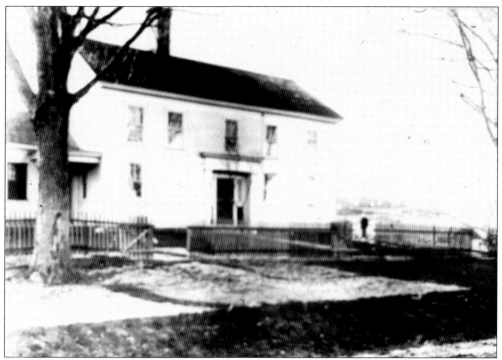

The John C. Porter house is located at the top of Porter hill on Route 61 South. Robert Porter's niece Marion Cowles was the last of the family to live in the house. (OBHS.)

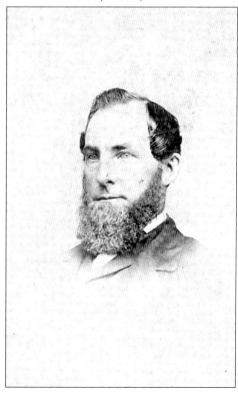

This is a photograph of D. C. Porter (OBHS.)

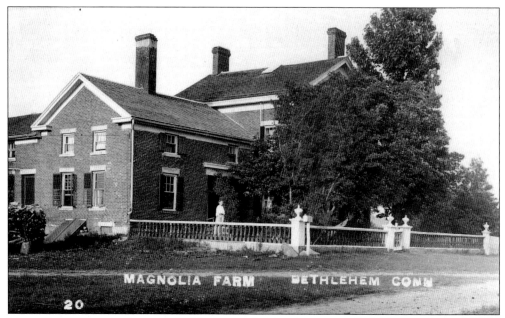

Magnolia Hill farm was home to the Thompson family, who came to Bethlehem in the mid-1700s. Dr. Ebenezer Thompson died in 1750 from the plague. Fred Thompson built the magnificent home at the intersection of Magnolia Hill Road and Hard Hill Road from bricks fired in the family's kiln. The magnolia trees seen in the front yard gave the farm and the house its name. (Mary Woodward.)

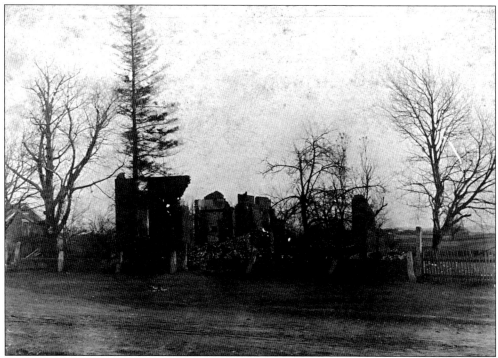

In 1926, the home was destroyed by fire. The farm's name was retained by Bruno Butkus, who once lived in the brick house and owned the farm. (OBHS.)

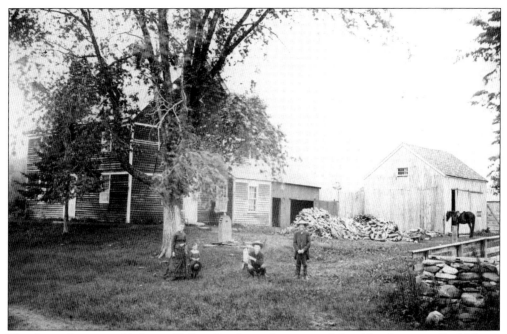

The Crane house at 120 Crane Hollow Road is perhaps one of the oldest homes in Bethlehem. This photograph shows the Allen family in 1886. From left to right are Mary E. Allen, May Allen Johnson, Samuel Allen, and Leslie P. Crane Sr. with dog Tige. The house was later home to the Kacerguis family, who still occupy it today. (Louise Johnson.)

May Allen married Albert Johnson and lived to age 102. She was active in town as a teacher at several one-room schoolhouses, a librarian, a Grange member for 83 years, a tax collector, and a member of Christ Episcopal Church. (Louise Johnson.)

The Bird house at 9 Wood Creek Road was built in 1780. This photograph was taken around 1900. (OBHS.)

This photograph shows the 1780 Bird house with the Alice Bird house across the street, built about 1860. (OBHS.)

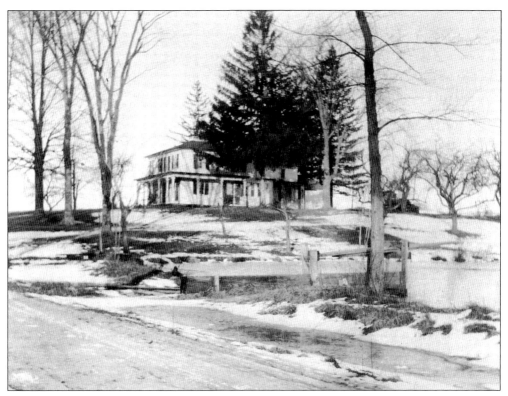

Aunt Alice Bird's house at 10 Wood Creek Road was known as the new house to distinguish it from the old house across the street. This was her home from 1872 until her death. She was a graduate of Mount Holyoke Seminary, a teacher, an organist, an active member of First Church of Bethlehem, and one of the town's first librarians. (OBHS.)

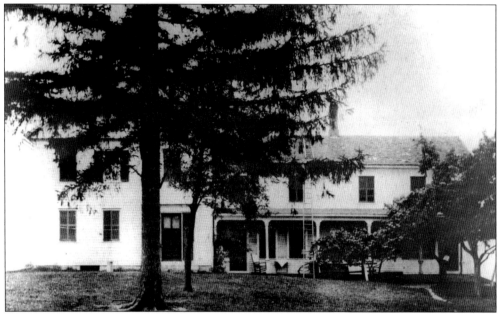

Lone Spruce farm is the Parmelee homestead located at 426 Guilds Hollow Road. The Parmelees were one of the earliest families to settle in Bethlehem. Charlie Parmelee remembers the grapevine extending to the pear tree on the right in front of the porch. When the original lone spruce pictured here came down, another was planted and is still there today. The family still owns the farm, which has been in the family since 1849. (OBHS.)

In February 1943, *Photo Story* magazine captured the hardy spirit of the town in World War II. "Like many other Bethlehem farmers, James T. Parmelee, whose son is in the Army, has been forced by shortage of farm help to turn to raising beef cattle." (Photograph by Michael Levelle.)

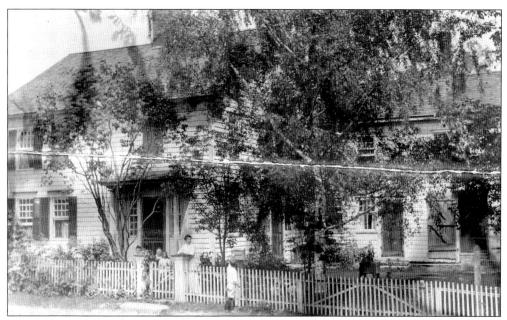

The Nehemiah Lambert Bloss house at 114 Carmel Hill Road was in the Bloss family for three generations from 1793 until 1916. The house was built in 1789 by Joel Hicock. (Agnes Johnson.)

In 1882, Bloss was prominent in Bethlehem. He was a lifelong Democrat, the town assessor for 20 years, and a selectman. As a child, he remembers the raising of the First Church of Bethlehem in 1838. He said he pulled flax in the morning and went to the raising in the afternoon, riding there on a horse. (OBHS.)

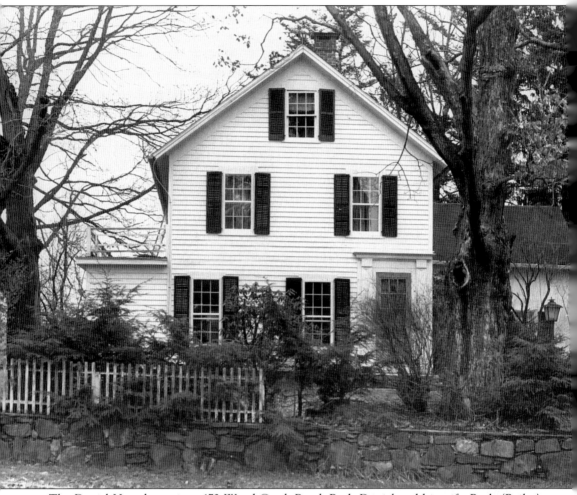

The Daniel Hunt home is at 172 Wood Creek Road. Both Daniel and his wife, Ruth (Bailey) Hunt, were born in England and came to Bethlehem in 1850. Daniel was a Civil War veteran who fought at Gettysburg, was taken prisoner, wrote letters from prison in Florida, and was paroled on August 25, 1863. His letters and Ruth's quilt are in the historical society's museum. (OBHS.)

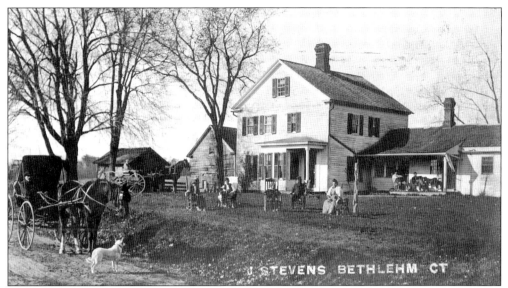

The J. Stevens home is located at 86 Bellamy Lane on the corner of Lake Drive. John L. Stevens was a rural route carrier from 1912 to 1923 when his brother Joseph Raymond Stevens took over until 1956. In those days, getting one's mail was sort of a social experience. (Mary Woodward.)

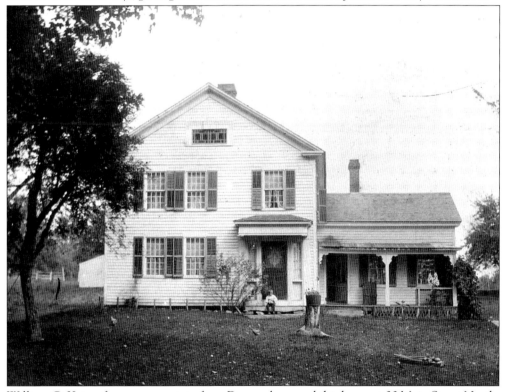

William C. Kair, a former sea captain from Denmark, owned this home at 30 Main Street North. His general store was just down the street. The home was later owned by the Root family, who saved the bell from the Methodist church and later donated it to the historical society. It was cast in 1860 by Naylor Vickers of steel. (OBHS.)

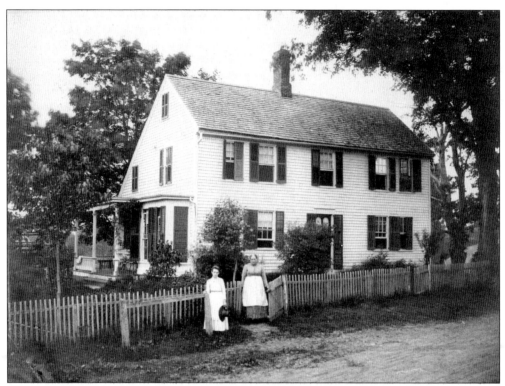

This home at 21 Munger Lane was Rev. Charles Brown's while he was pastor at Christ Episcopal Church. The house was owned by Caroline Woolsey Ferriday. (OBHS.)

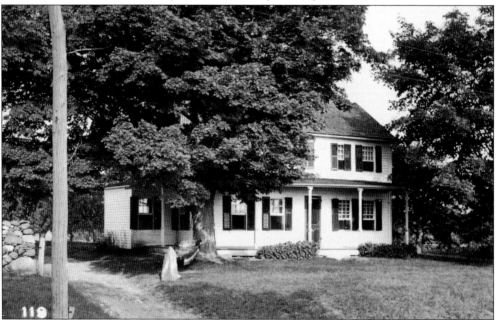

Sheldon C. Seavitt may have built this home at 122 Main Street South around 1829. Later owned by the Jacksons, the home was also once owned by the Minor family, according to Fenn Quigley. (OBHS.)

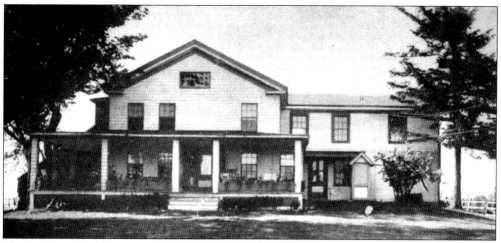
Charles Beardsley's house at 45 Kasson Road was built as a summer home. (OBHS.)

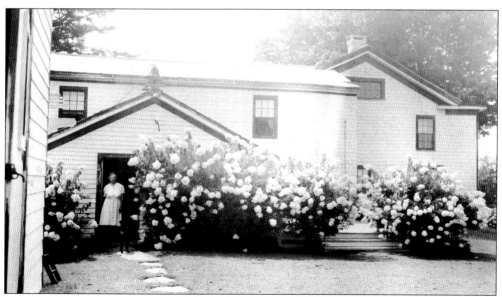
Mrs. Charles Beardsley is pictured at her back door with hydrangeas in bloom. (OBHS.)

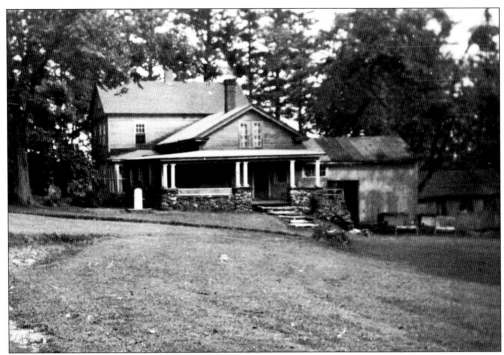

James Benedict's home was at 198 Hard Hill Road before it was destroyed by fire. (OBHS.)

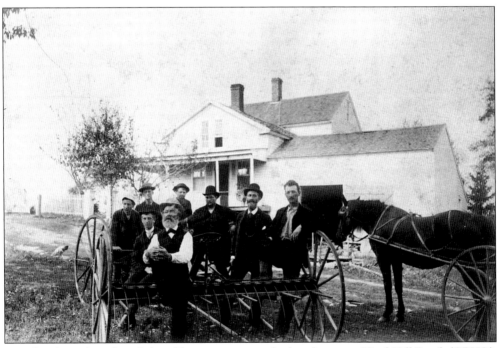

Benedict (seated on the rake) and his sons are outside their home on Hard Hill Road. (OBHS.)

Two

BUSINESS AND INDUSTRY

George S. Guild, with his brother
Leland A. Guild, built Bethlehem's
first industrial complex in Guilds
Hollow. (OBHS.)

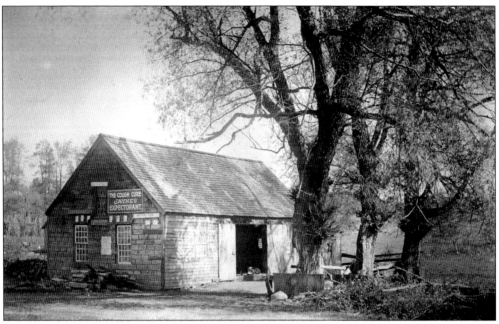

This 19th-century blacksmith shop, located on Main Street across from the present town office building, was owned by Frederick Candee. One of the three horse watering troughs was located here. (OBHS.)

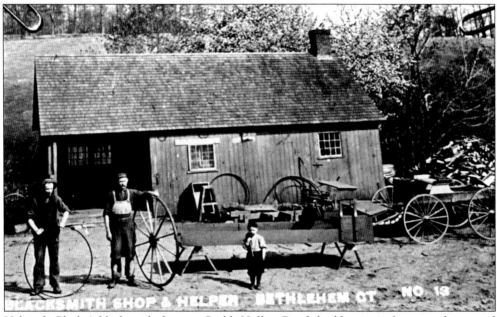

Helmuth Glosky's blacksmith shop on Guilds Hollow Road shod horses and oxen and prepared metal for most common house and farm needs of the day, such as hinges and wagon wheel rims. Pictured is the Glosky family, who owned the shop for many years. The building became the studio of artist Ralph Nelson after 1940 and still stands across from his home, now owned by his daughter Carolyn Nelson Gonzales. (OBHS.)

Only one canning company was located in Bethlehem, owned and operated by the B. S. Johnson family on East Street. (OBHS.)

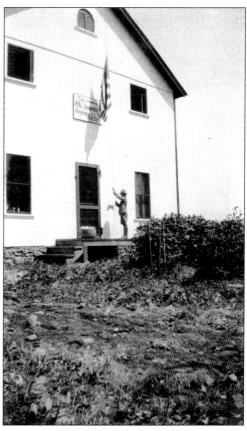

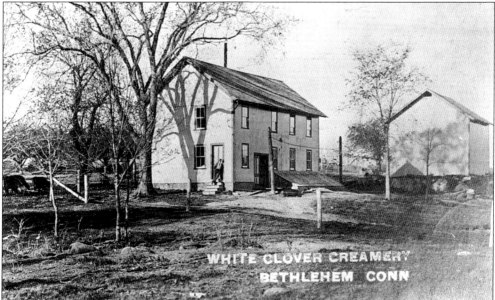

White Clover Creamery on West Road (Route 132) was run by Jesse W. Smith when he had one of the largest dairy farms in Bethlehem. The building on the right is the icehouse supplied by Bird Pond. Smith retired from farming in 1929 at age 70. (OBHS.)

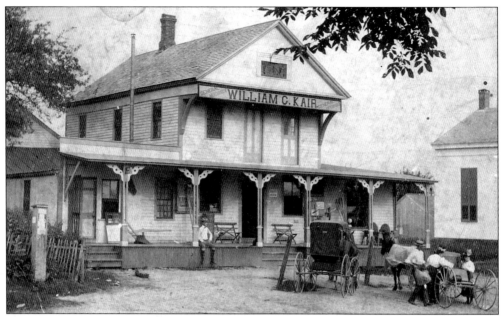

Bethlehem's oldest mercantile building's exact age is unknown. However, a weekly area newspaper dated May 10, 1830, carried an advertisement by owner Coant Carlin, who listed the location as, "an eligible stand for merchant or mechanic." Acquired in 1876 by William C. Kair, a retired ship captain from Denmark, the building burned down around 1904. Soon after, Arthur T. Minor rebuilt it. The post office was located here with Herbert S. Jackson as postmaster in 1868. It is now Theo's Pizza. (OBHS.)

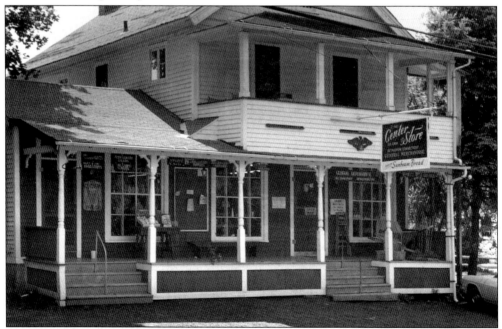

Minor's General Store (the center store) was a gathering place around the potbelly stove. Carolyn Nelson Gonzales observed in her book of essays on Bethlehem that Johnson's store was the center for the Democrats and Miner's for the Republicans. (Edna Miller.)

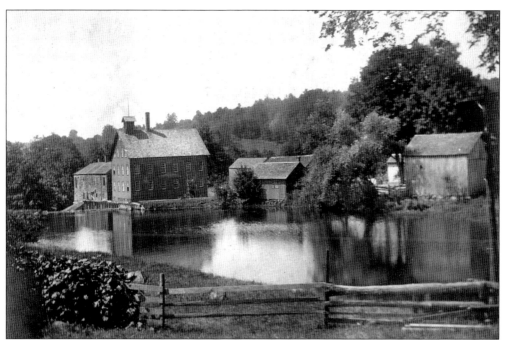

The Guild family purchased the millpond and factory site in Guild Hollow sometime in the first half of the 19th century. Listed on an 1859 map was the C. O. and L. H. Guild Wagon and Sleigh located on Mill Pond Road on the Weekeepeemee River. Horse carriages were also made. The building burned in the early 20th century. The factory was powered by water, and all that remains today are the pond, dam, some of the factory foundations, and a few renovated buildings seen in the photographs. (OBHS.)

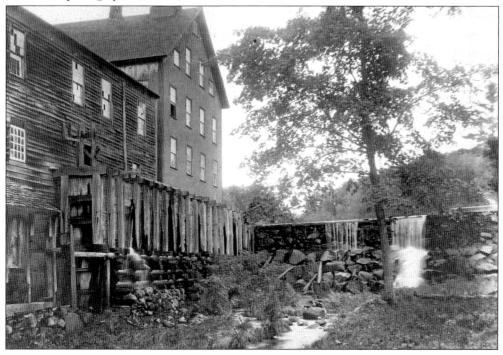

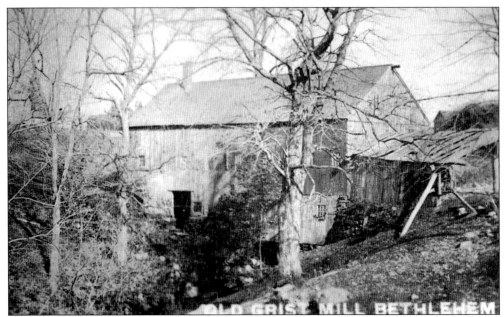

Harvey Gillette's gristmill, built between 1820 and 1830, was located three-quarters of a mile west of the green on Route 132. The most successful industry until the late 1800s, it processed corn, rye, and oats. It paid the most taxes and used the most waterpower from Bird's Pond and Long Meadow Pond. The mill operated until 1913 but became badly deteriorated by 1950. (OBHS.)

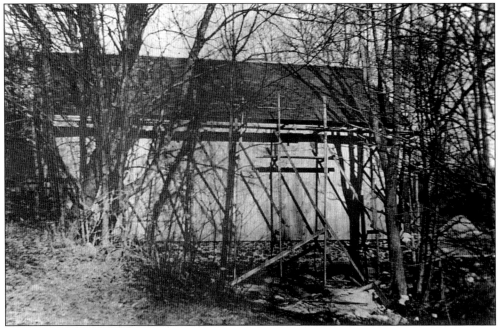

There was a cheese factory one mile off Thomson Road in 1903. Frederick R. Thomson, whose father had the farm at the end of the road, returned to Bethlehem and built a cheese factory. In the spring of 1910, the dammed-up stream was swollen by unusually heavy rains and flooded the building where the cheese was aging. The building's timbers were used in the new cannery being built on East Street by B. S. Johnson. (OBHS.)

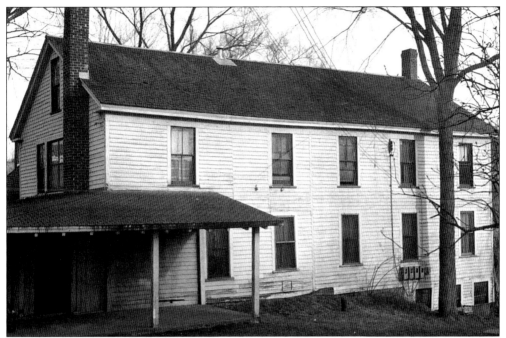

The old fulling mill was constructed in 1820 by Joshua Bird on land purchased from Jonathan Ingersoll. His Satinette factory was located south of Bird's Pond and operated as a woolen mill from 1820 to 1890, providing uniforms for soldiers in the Civil War and later school uniforms. (OBHS.)

The woolen mill was also an early town laundromat. On Mondays it was used to do large and heavy washing for the housewives of Bethlehem. With unlimited cold running water from the pond and big dye vats full of boiling water, it cost 25¢ to have the washing done—soap included. Farmers could also sharpen their scythes and knives on its grindstone. Only the foundation of the mill remains. (OBHS.)

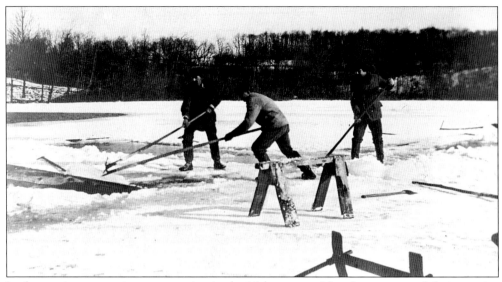

Ice harvesting was a winter occupation in the 19th century. Most farmers owned their own ice ponds, but with the creation of Bird's Pond and Zeigler's Pond, ice harvesting became a major industry. (OBHS.)

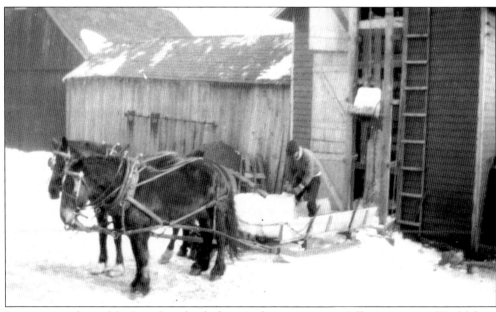

Ice was not only used for farms but also for home refrigeration, especially since most of Bethlehem had no electricity until 1940. (OBHS.)

Bethlehem resident Robert Leather was founder of Lea Manufacturing Company in 1923 in Waterbury. The company made greaseless industrial compound. Leather resided on Flanders Road. (David Kacerguis.)

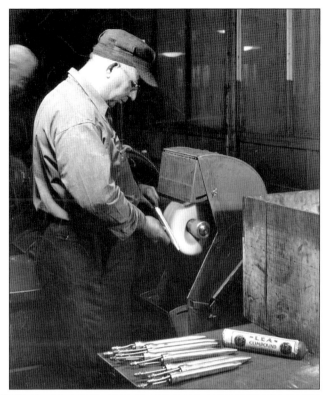

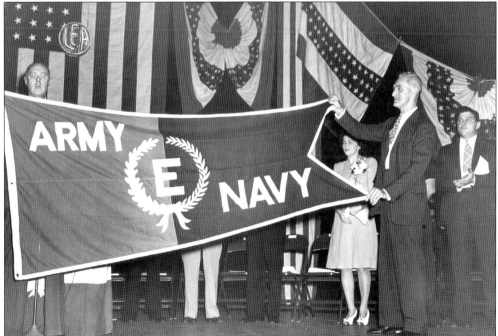

In June 1944, the company's employees were given the Army-Navy E award for meritorious service, indicating the importance that proper finishing played in the production of war implements. Robert Leather is at the far left in this photograph. (David Kacerguis.)

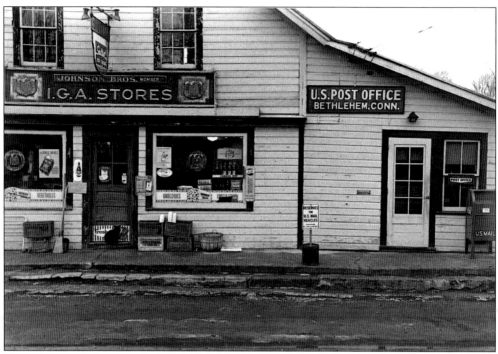

Henry Johnson's Store was located on Main Street North. It also housed the post office, presided over by Henry's brother Earl. Below was space for Bethlehem's itinerant barber. (Edna Miller.)

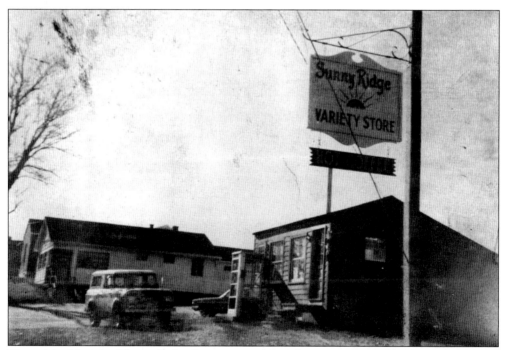

The original home of Sunny Ridge Superette on Main Street was opened by Steve and Muriel Meehan in 1966. This small building previously housed a real estate business and cigar shop. It was torn down when the superette moved into a new building in 1968. (Steve Meehan Jr.)

Three

RELIGION

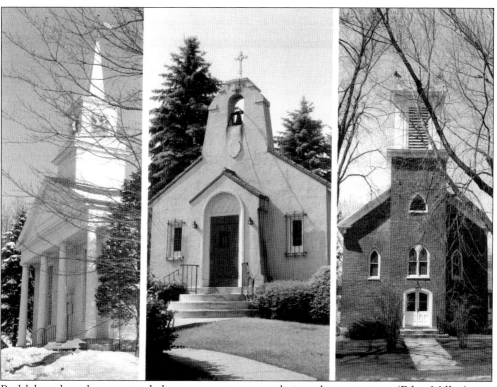

Bethlehem has always extended open arms to every religious denomination. (Edna Miller.)

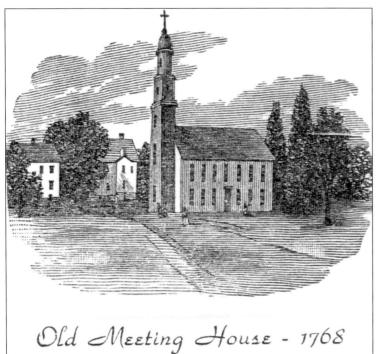

Old Meeting House - 1768
Bethlehem, Conn.

The first meetinghouse was a barn in which young Joseph Bellamy first preached. It was located on the corner of the east–west road that is now Kasson Road and Lakes Road. The second meetinghouse was only a few rods away from the first and was built of brick. In 1768, a new meetinghouse was built on Bear Hill, as the green was then known. (FCB.)

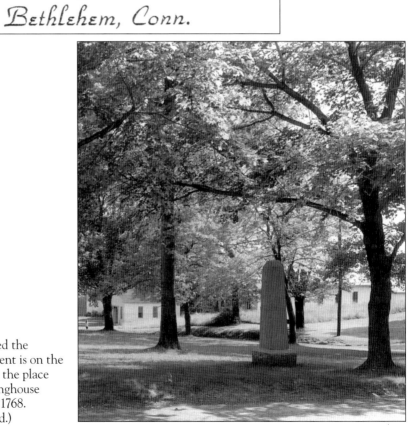

The obelisk called the Bellamy Monument is on the green and marks the place where the meetinghouse was relocated in 1768. (Mary Woodward.)

The inscription on the monument reads as follows: "Erected July 4, 1890. Here stood the meeting house where Dr. Bellamy ministered 1767–1790." (FCB.)

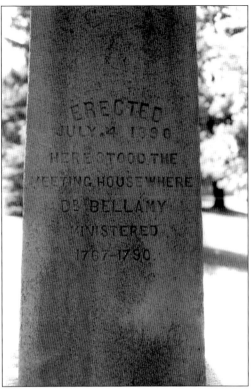

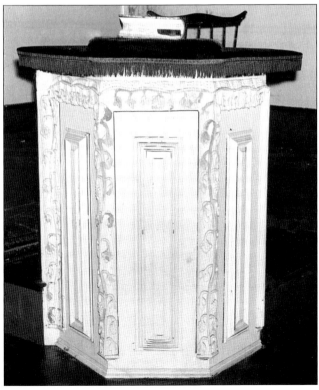

According to the notes of First Church of Bethlehem historian Rena Waite, "the Bellamy Pulpit was taken from the old church October 2, 1768, and stored in the parsonage attic. After being redressed, it was again placed in the church November 14, 1909, one hundred forty one years after it was built." This hand-carved pulpit is believed to be the only intact pre–Revolutionary War one in Connecticut and possibly New England. (WRA.)

39

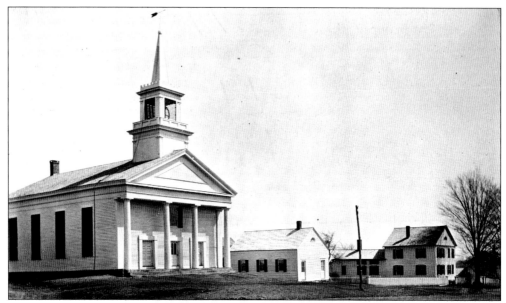

This First Church of Bethlehem photograph, taken between 1900 and 1910, includes the chapel (center, also called the Sabbaday house and built in 1835) and the parsonage (far right, built in 1830). For many years, the chapel was used for Sunday school before Bellamy Hall was built. In 1925 and 1926, the sixth, seventh, and eighth grades of the public schools met here. Note the three doors at the front entrance of the church. The right and left doors were later made into windows. (FCB.)

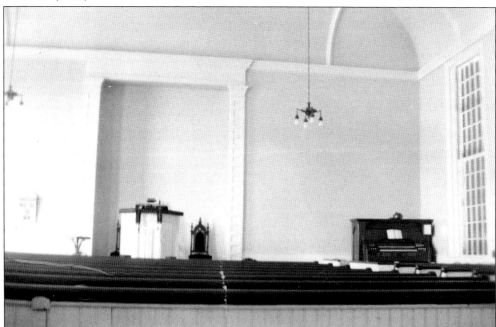

The interior of the First Church of Bethlehem with the Bellamy pulpit is pictured here. After the Methodists merged with the First Church in 1920, this Methodist pulpit was often preferred by pastors because it was smaller and shorter than the one used by six-foot-five Rev. Joseph Bellamy. (FCB.)

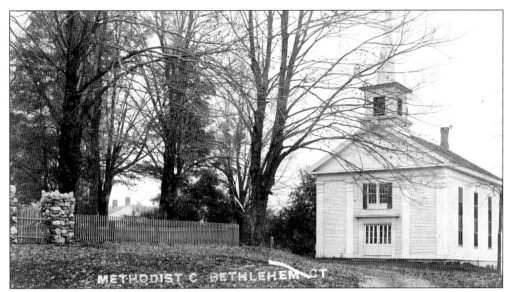

The Methodist Episcopal Church, located at the corner of Routes 132 and 61, was built in 1860 and dedicated on November 14, 1860, when the population of the town was 815 people. The population decreased to 536 in 1920, and the church merged with the First Church of Bethlehem. In 1929, the building was sold for $55 and torn down. Only the bell and a few foundation stones remain at the original site, upon which the town hall was built in 1941. The town hall was designed by George Hatch. In 1976, the town sold the building to the Old Bethlem Historical Society. (OBHS.)

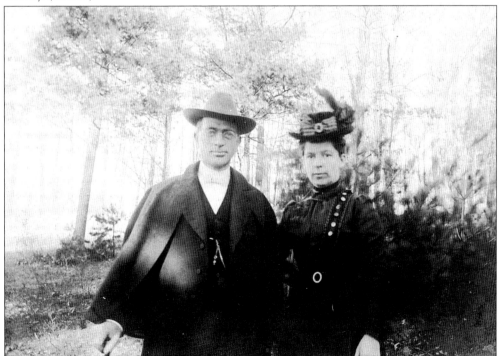

Rev. Frank Adams was pastor of the Methodist church in 1894. Here he is pictured with his wife. They lived in the Azel Backus house on the opposite corner. (OBHS.)

Christ Episcopal Church was first mentioned in the town records as follows: "On March 13, 1807, in response to a petition signed by eighteen names, David Bellamy, justice of the peace, gave to Daniel Skidmore the necessary warrant for holding a meeting to organize a parish of the Episcopal Church. This, the first regular parish meeting, was held at 1 P.M., March 30, 1807 at the house of Amos Lake." (Betty Bloss Barbour.)

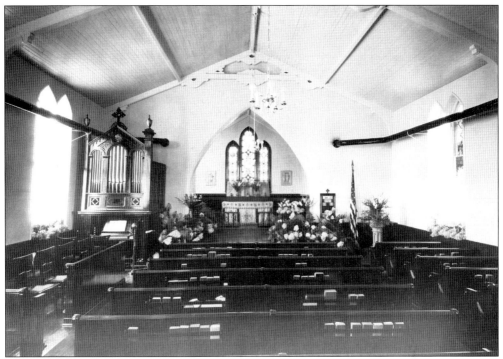

Here is the interior of Christ Episcopal Church, decorated for the marriage of Dorothy Hill and Lester Bronson in 1927. Later the center aisle was restored after the stoves were replaced. In 1849, the bell in the church was purchased from the West Troy Foundry at a cost of $288.88 and a weight of 938 pounds. (OBHS.)

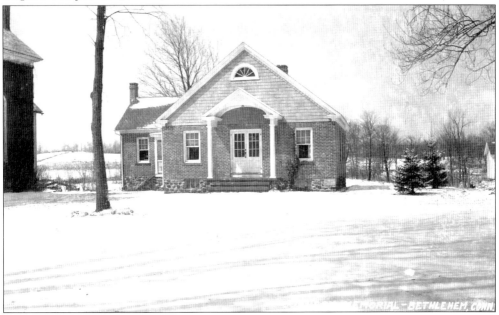

On land donated by James and Mary (Carpenter) Flynn, Johnson Memorial Hall was built in 1931. It was named in memory of senior warden Albert Johnson and the Lake family. (Betty Bloss Barbour.)

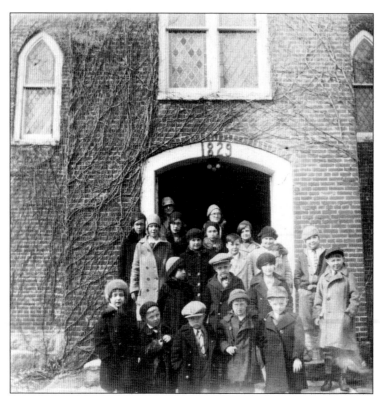

In this undated photograph, a Sunday school class assembles at the front door of Christ Episcopal Church. (OBHS.)

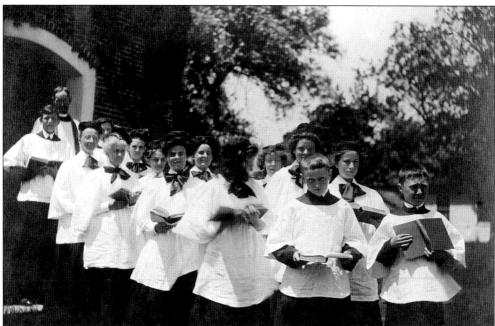

Here is the Christ Episcopal Church choir at the front door. Pictured from left to right are (first row) Rev. Clarence Beers, Clark Kichberger, Mrs. Nelson Flower, Myra Hurlburt, May Allen Johnson, Hulda Beers, Sanford Smith, and Gardner Johnson; (second row) John Beers, Manie Johnson, Edith Cote, Edith Lane, Bonnie Bell Juts (teacher), Mary Beers, and Josephine Smith. (OBHS.)

In 1966, the Litchfield Hunt Club was invited to the Christ Episcopal Church Thanksgiving service, where, at the south end of the green, the vicar blessed the hounds prior to a hunt. This tradition continued until 1997. (WRA.)

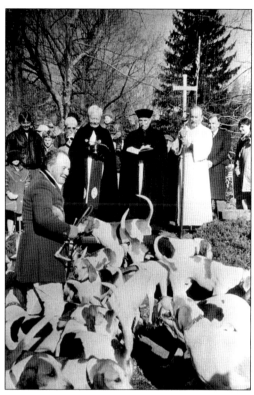

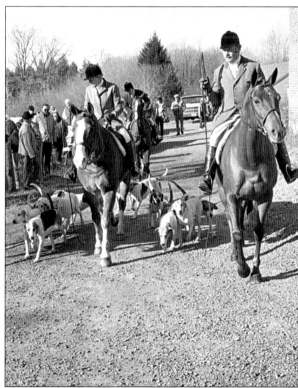

The hunters parade around the green and then out across the roads and fields of Bethlehem. John LeMay, master of the hounds, leads the hunt. (WRA.)

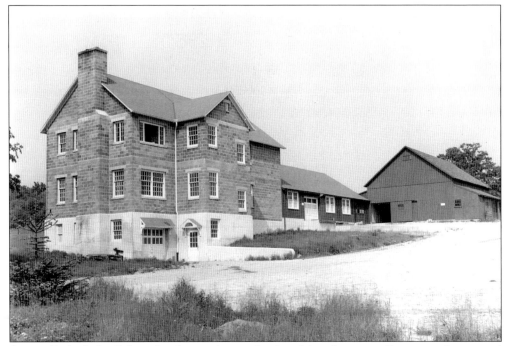

Originally built by Robert Leather to house the Lea Manufacturing Company, the unused building on Flanders Road was donated to the Benedictine nuns for the founding of the Abbey of Regina Laudis in 1947. (WRA.)

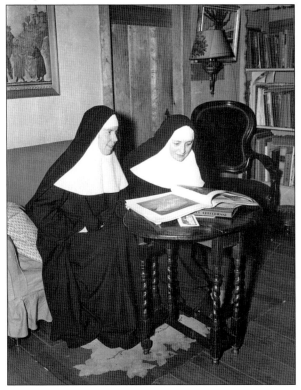

Mother Benedict Duss (left) and Mother Mary Aline (right) founded the Abbey of Regina Laudis together after leaving postwar France in 1946. (WRA.)

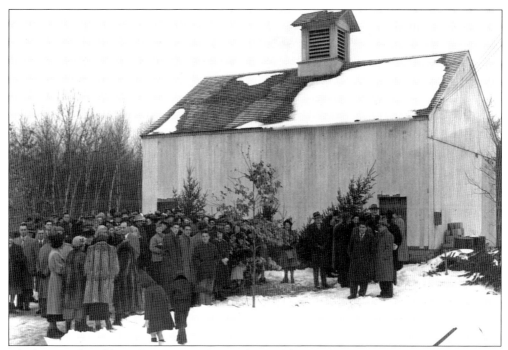

The barn at the Abbey of Regina Laudis was donated by Caroline Woolsey Ferriday and moved from her property near the green. The 1720 Neapolitan crèche, donated by Loretta Hines Howard in 1949, is housed there. (WRA.)

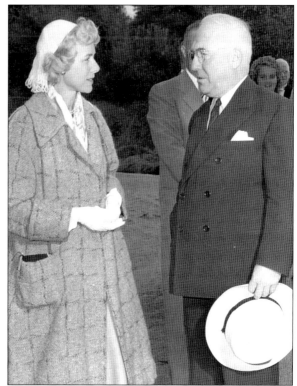

Claire Booth Luce, author of "Come to the Stable," a short story based on the founding of the abbey, is shown here with Judge Malloy at the enclosure ceremony in September 1948. Later the movie *Come to the Stable* was made with Loretta Young and Celeste Holm, who won an Oscar for best supporting actress. (WRA.)

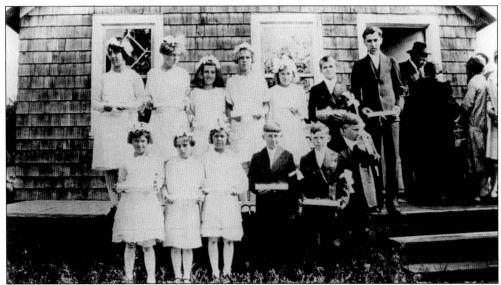

First communion at the Mission Church in 1927 was held in the town's pool hall. Pictured from left to right are (first row) Antoinette Kacerguis, unidentified, Alice Skeltis, Edward Lizauskas, Adam Lizauskas, and J. Budris; (second row) Sadie Tanuis, unidentified, Mary Tanuis, N. Budris, unidentified, Vincent Kacerguis, and Akle Tanuis; (in the doorway) Thomas Marchukaitis, Rose Mazaika Marchukaitis, Magdalena Marchukaitis Lizauskas, and Anna Marchukaitis Kacerguis. (Antoinette Keilty.)

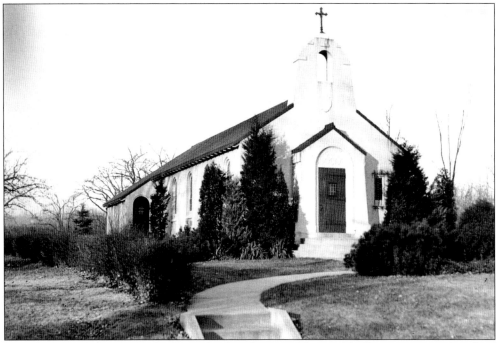

Church of the Nativity was built on the foundation of the pool hall as a mission church of St. John's in Watertown, which ministered to the small parish of immigrant Lithuanian and Lebanese who came to Bethlehem in the early 20th century. This photograph is from about 1937. (WRA.)

Four

EDUCATION

The Hard Hill Schoolhouse was demolished in 1973. John Greenleaf Whittier wrote the following: "Still sits the schoolhouse by the road, / A ragged beggar sunning; / Around it still the sumac grow, / And blackberry vines are running." (OBHS.)

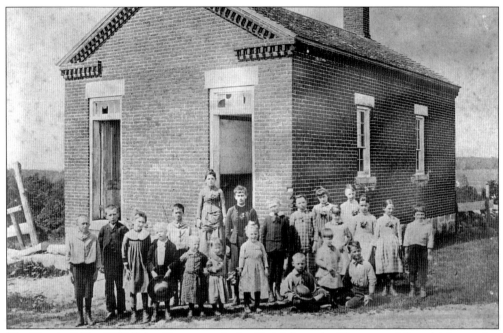

The District 2 Hard Hill Schoolhouse was built of brick from the Thompson kiln, which was also on Hard Hill Road. This class has young Mary L. Ames as its teacher (standing in the doorway). Also identified is Julia Thompson Bath, as "the child with the cropped hair in the middle row," whose grandfather Fred Thompson fired the bricks for the structure. (Charlie Pack.)

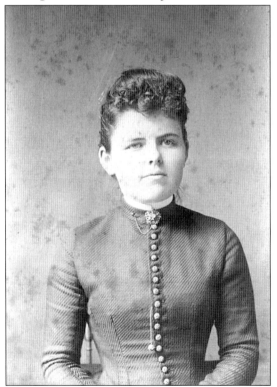

Ames was the daughter of local farmer James Ames, the wife of Arthur T. Minor, and the mother of Ames Minor. Other teachers listed at Hard Hill Schoolhouse included Anna Hard (1862), Sarah Skidmore (1861), Carolena Blackman (1861), Maria Peck (1859), J. Knight Bacon (1858), and E. De Witt Rigg (1859). (OBHS.)

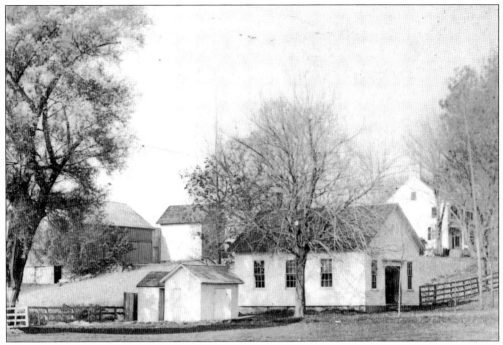

The District 1 schoolhouse was in the center of town next to Christ Episcopal Church around 1850. Argull Hull etched his name in one of the windows, and Flossy Box left her name on one of the walls, both of which are still there today. (Mary Woodward.)

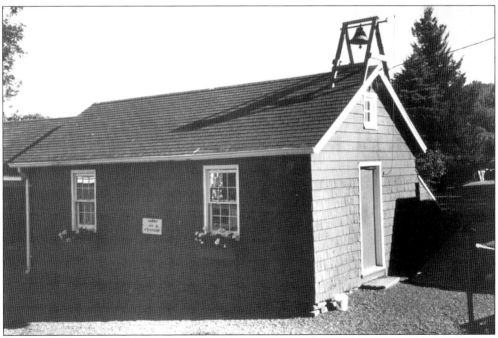

District 7 North Carmel Hill School was originally located near the corner of Still Hill Road and Carmel Hill Road North. Later William Ruane moved it to his home at the corner of Wood Creek Road and Carmel Hill Road, where it stands today. (OBHS.)

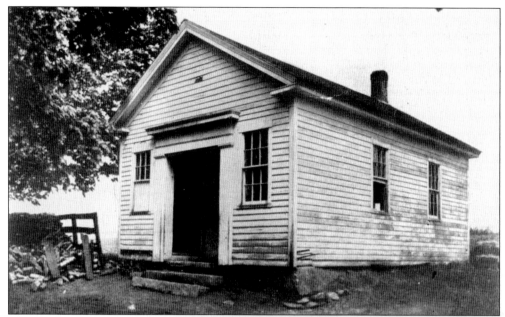

District 6 Kasson School was built in 1843 at the corner of Kasson Road and Lake Road by Daniel B. Jackson, just west of the original 1794 building, for the sum of $222. (OBHS.)

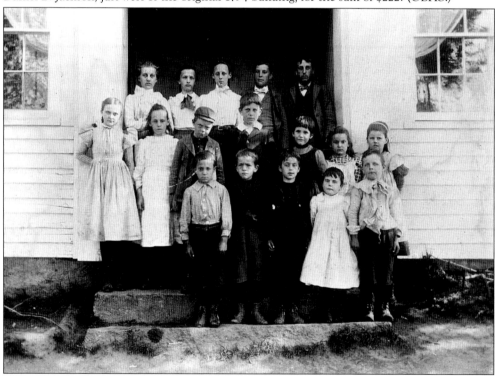

This is Miss Atwood's class at the Kasson School around 1890. From left to right are (first row) Jesse Smith, Walter Lake, Leroy Sanford, Viola Minor, and Roger Minor; (second row) Bernice Johnson, Emma Smith, Fred Judd, Harold Thompson, Ina Lake, Edith Lake, and Ethel Minor; (third row) Atwood, Belle Thompson, Phoebe Smith, Welton Thompson, and Robert Lake. (OBHS.)

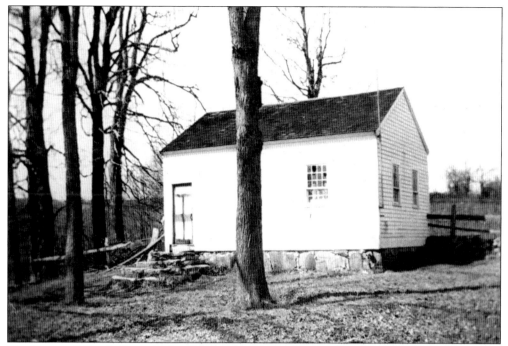

The District 5 South Carmel schoolhouse was on Guilds Hollow Road. The 1870 stove is now in the District 1 schoolhouse museum. James T. Parmelee (born in 1875) attended all eight grades and tended the stove, as did his son Earle. In 1938, James bought the schoolhouse and 50 acres of land for $1,000, according to Earle's scrapbook. (OBHS.)

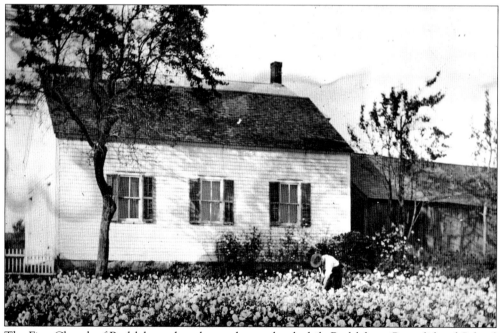

The First Church of Bethlehem chapel served as a school while Bethlehem Consolidated School was being built. (OBHS.)

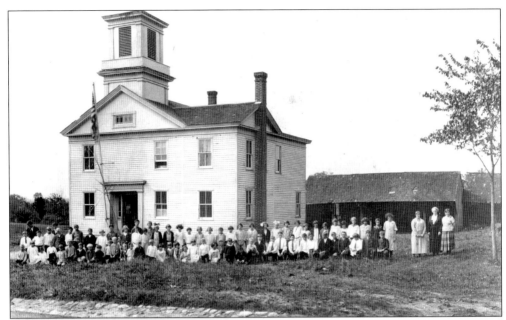

Constructed in 1840 as a town office building on Jackson family land south of Christ Episcopal Church, the upstairs was the select school for students able to go beyond the eighth grade. In 1941, the town offices moved to the brick building that is now the historical society's museum. Eventually the building became the American Legion. (OBHS.)

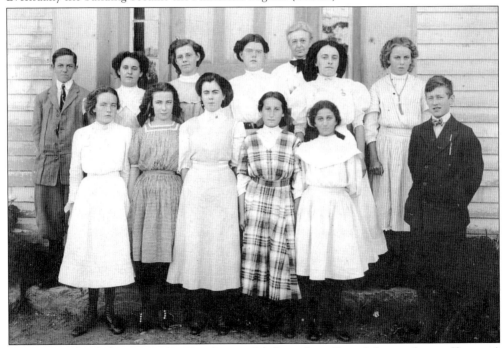

The select school class in 1909 is standing at the front door. From left to right are (first row) Mary New, Gladys Blakeman, Viola Minor, Jennie Blakeman, and Ida Blakeman; (second row) William Smith, Edith Lake, Blanche Woodward, Mildred Judd, teacher Mrs. Ives, Bertha Hollenbach, Gerta Anderson, and ? Goodson. (OBHS.)

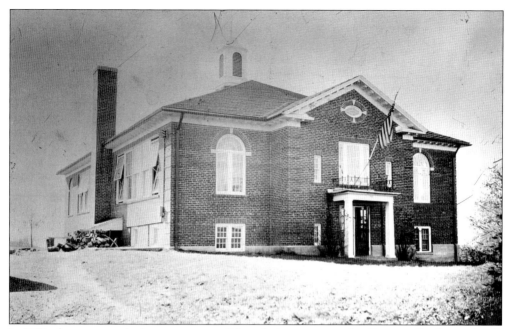

In 1922, the state required towns to consolidate their one-room schoolhouses. On September 7, 1926, Bethlehem Consolidated School opened with four classrooms and 93 students in grades one through eight. The inner walls are built with brick from the Thompson's kiln, which was on Hard Hill Road. (OBHS.)

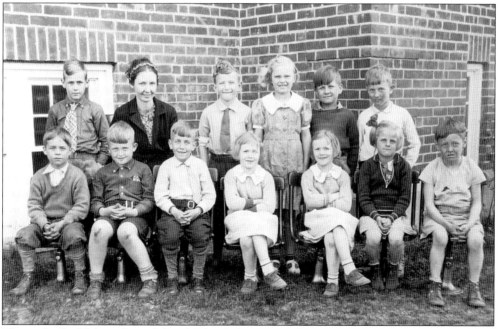

This is the Bethlehem Consolidated School elementary class in 1936. Pictured from left to right are (first row) Douglas Stoughton, Curtis Bate, Walter Hunt, Shirley Box, Helen Box, Leona Courtot, and Robert Munson; (second row) Roger Wiltshire, Ruth Miller (teacher), N. Arthur Hunt, Katherine Owen, Jack Traub, and Arthur Stoughton. (Walter Hunt.)

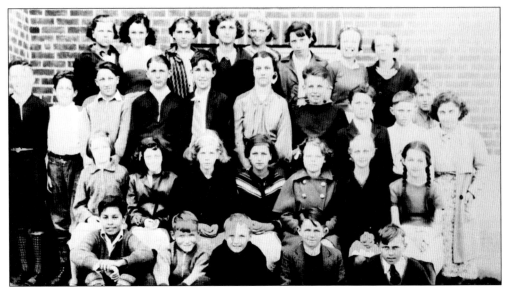

This is a photograph of combined grades at Bethlehem Consolidated School in about 1938. From right to left are (first row) Wesley Meskun, Vernon Box, Dick Ruppel, Billy Smith, and Eddie Skelte; (second row) Helen Kacerguis, Margaret Woolsey, unidentified, Anna Kacerguis, Jean Stevens, Ruth Anderson, and Dorothy Johnson; (third row) Allan Woodward, unidentified, Billy Alexson, Lewis Parmelee, Elwood Lynn, Mrs. Dovadaitis (teacher), Teddy Traub, Willy Munson, Paul Maddox, unidentified, and Rose Tanuis; (fourth row) Bernice Yonkaitis, Alice Gunning, Alice Zeigler, unidentified, Doris Anderson, unidentified, June Traub, and Nellie Zemaitis. (OBHS.)

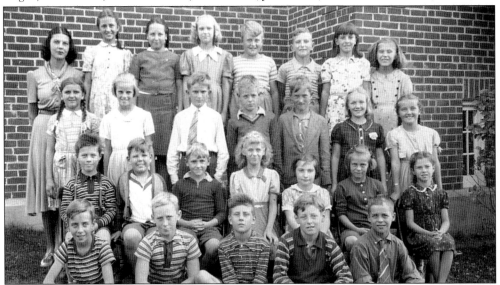

The sixth, seventh, and eighth grades are pictured in this photograph from about 1943. From left to right are (first row) Walter Hunt, unidentified, Royal Shade, Robert Munson, and Douglas Stoughton; (second row) unidentified, Gerald Minor, Robert Box, Dolores Douch, Helen Mann, Marion Satula, and Mary Ann Perrett; (third row) Marie Kacerguis, Leona Courtot, Robert Maddox, Hugh Bronson, Arthur Stoughton, Shirley Box, and Lucy Jacobs; (fourth row) Ruth Peel (teacher), Martha Buzaid, Sally Lorensen, Katherine Owen, Curtis Bate, N. Arthur Hunt, Reba Kelly, and Helen Kalvaitis. (Walter Hunt.)

Five

AGRICULTURE

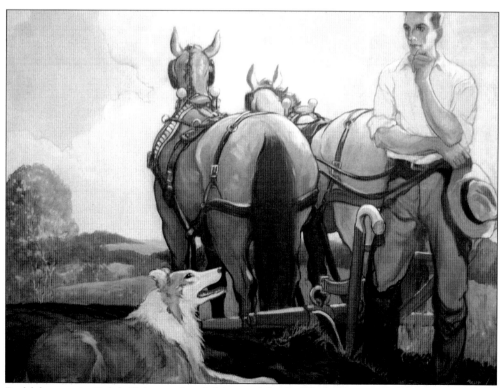

Bethlehem artist Ralph Nelson painted this mural for the Works Progress Administration in the 1930s. It is now in the East Hartford Library. (Vincent Bove.)

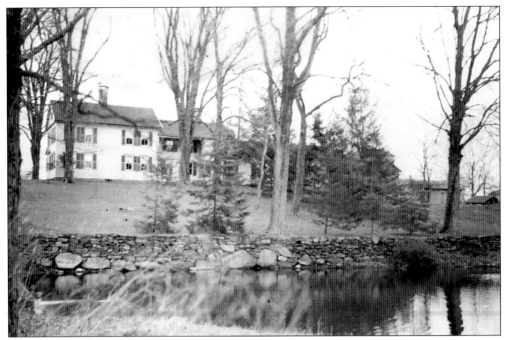

The Walter F. Bloss home is at 18 East Street with the Bloss Duck Pond in the foreground. (Betty Bloss Barbour.)

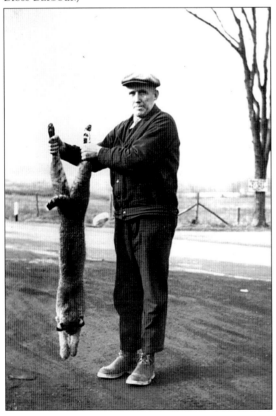

Bloss is shown with his trophy bobcat that most likely was preying on his livestock. Historically bobcats were not protected and were viewed as a threat to agriculture and more desirable game species. Bloss also raised mink and silver fox on his farm. (Betty Bloss Barbour.)

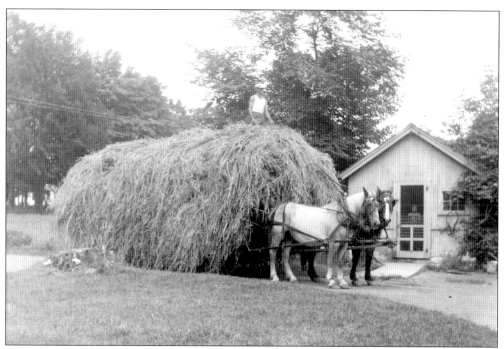

Gathering hay on the Bloss farm was done with pitchforks. This photograph shows the milk house outbuilding on the farm, which became the Christmas shop when Sheldon and Joan Smith bought the property many years later. (Betty Bloss Barbour.)

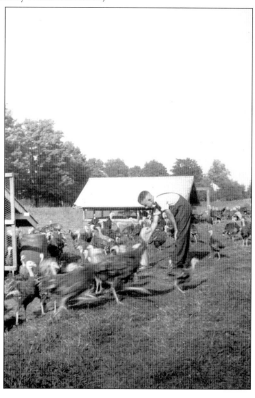

Bloss also raised turkeys on his East Street farm. (Betty Bloss Barbour.)

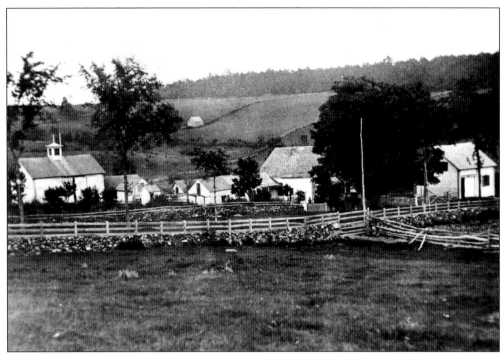

The Nathan Bloss farm on Munger Lane is shown here around 1890. It was later bought by Lithuanian immigrant Andrew Kacerguis and by Thomas Marchukaitis in 1915. (OBHS.)

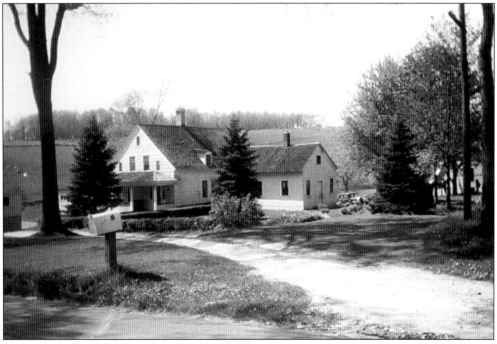

This is the original farmhouse on the Nathan Bloss farm. Later known as March Farms, Thomas and Rose Marchukaitis's grandchildren and great-grandchildren still live and work the property, raising apples, peaches, and blueberries. (Thomas March.)

This photograph shows Rose (Mazaika) Marchukaitis and her husband, Thomas, in later years. (Thomas March.)

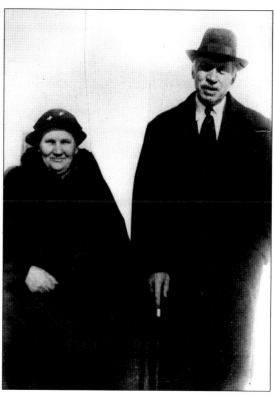

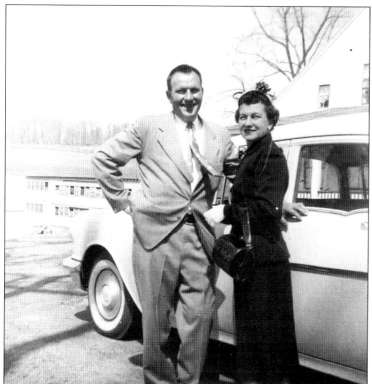

Matthew and Anastasia (Skeltis) March are shown in 1955 with their new Buick. Matt was active on the Litchfield County Dairy Commission, the board of assessors, the school board, and the volunteer fire department, as well as a trustee of the Church of the Nativity. (Thomas March.)

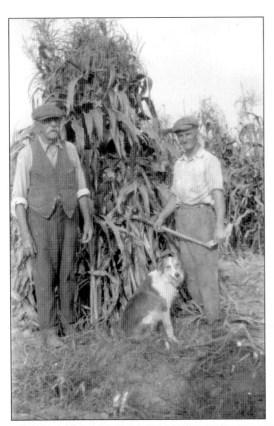

From left to right, Joseph Hunt and Henry Box are cutting corn at Elmwood Farm on the corner of Kasson Road and Lakes Road. (Walter Hunt.)

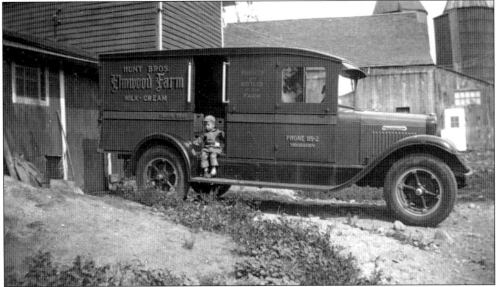

Elmwood Farm's milk truck is pictured here with young Walter Hunt on the running board. The farm has been in the Hunt family for six generations going back to 1850, when Christopher Hunt came from England and bought the historic Kasson farmhouse and land. His grandson Warren Hunt (1898–1972) served as first selectman and a member of the Connecticut General Assembly. (Walter Hunt.)

Six

ROADS AND
PUBLIC BUILDINGS

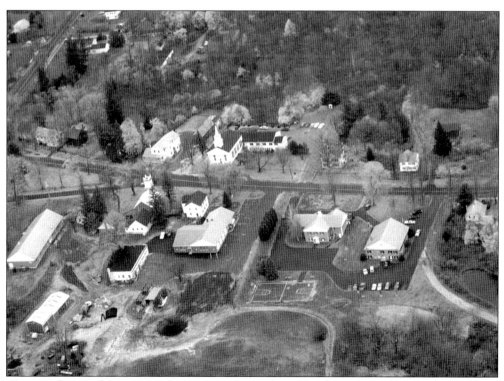

This aerial view of the center of town was taken by Lori Hart from an airplane piloted by Frank Gallagher around 1970. (FCB.)

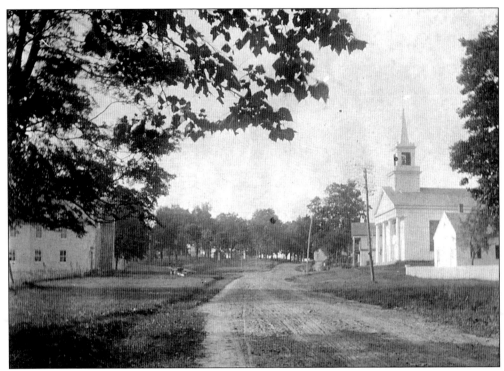

Shown here is Main Street around 1900. (OBHS.)

Bird Pond was built in 1802 to provide water for the fulling (shrinking and thickening of wool by moistening, heating, and pressing) mill that Silas Lewis had moved up from Wood Creek. Joshua Bird bought it a few years later and operated it as a woolen mill, closing it in the 1890s. The pond also supplied water flow for a gristmill and the factories in Guild's Hollow. In 1846, Long Meadow Pond was constructed and water rerouted into Bird's Pond to assure a steadier flow of water not only for the woolen mill but also for all the mills and factories into Hotchkissville in Woodbury. Chess sets were also made later in the woolen mill building. (OBHS.)

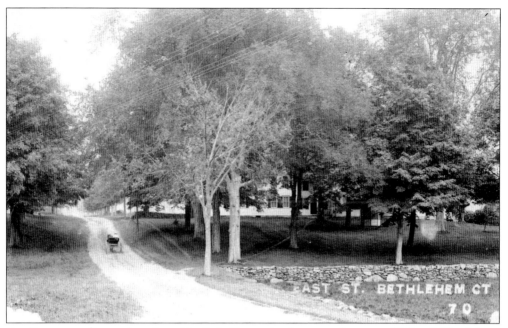

East Street as a dirt road ran from Doolittle Corner by the green down past Walter F. Bloss's farm and out the east–west Kasson Road, now route 132. (OBHS.)

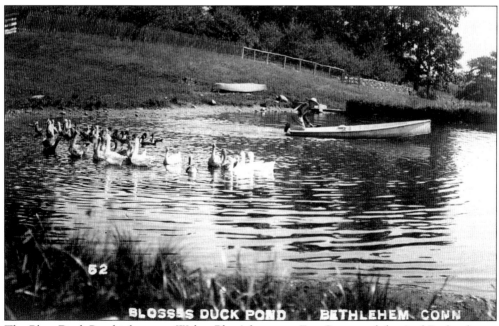

The Bloss Duck Pond is between Walter Bloss's house on East Street and the Azel Backus house on the corner of Routes 61 and 132. (Betty Bloss Barbour.)

Main Street South went in front of the Evergreen Cemetery past the former gasoline station. Today Flanders Road is perpendicular to Main Street, but some of the large maple trees still remain. (OBHS.)

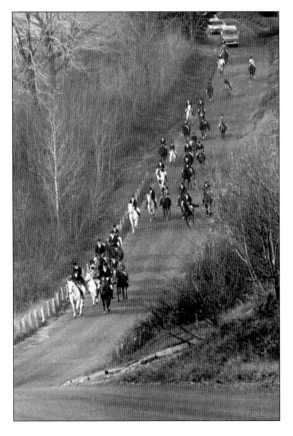

On Thanksgiving Day, Green Hill Road was part of the route of the hunt after the blessing of the hounds on the green. (Edna Miller.)

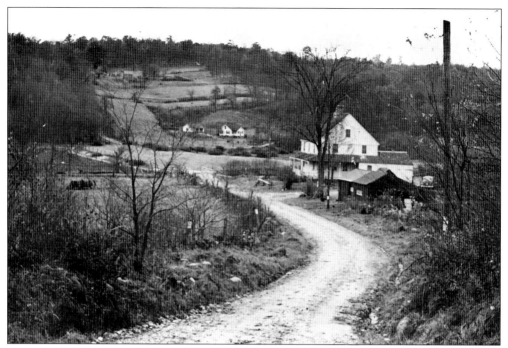

Crane Hollow Road is named for the Crane farmhouse at the bottom of the hill coming down from Flanders Road. The road crosses the Weekeepeemee River and continues up the opposite side. (OBHS.)

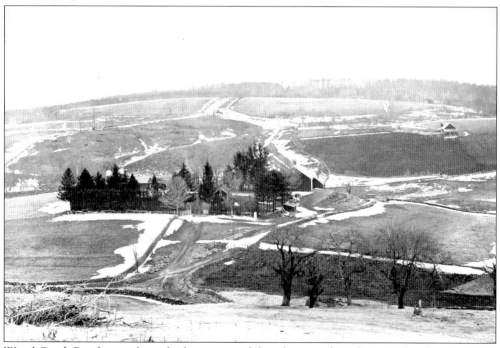

Wood Creek Road runs along the lower part of this photograph with Carmel Hill Road North going perpendicular down past the Captain Scott-Zeigler-Ruane house. To the right is Zeigler's Pond. (OBHS.)

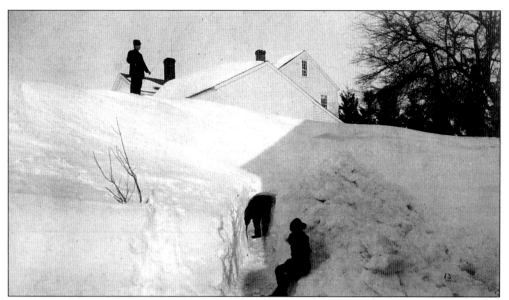

The blizzard of 1888 lasted from March 12 to March 14. This photograph of the Benedict farm on Hard Hill Road North shows Edgar Benedict on top, Samuel Benedict Sr. in the tunnel, and eight-year-old Neal Benedict Jr. sitting down in the foreground. (OBHS.)

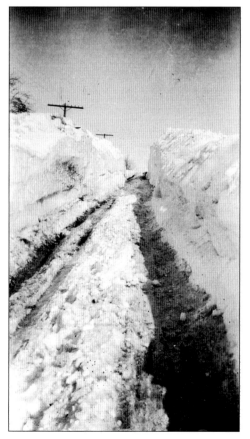

This photograph of Sanford Hill at the corner of Nonnewaug Road and Magnolia Hill Road after a blizzard in 1926 shows the dirt road with walls of snow on both sides. (OBHS.)

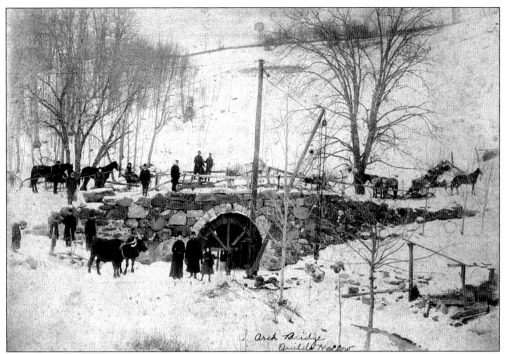

Arch bridge was built in 1886 and 1887 at a cost of $1,050. This 1887 photograph was taken near its completion. The beautiful stone arch was built over Wood Creek, which flows into the Weekeepeemee River. The Old Bethlem Historical Society, whose president is Doris Black Nicholls, and the town of Bethlehem, restored it in 1987. Several members of the Parmelee family are included in this picture. On the bridge left of center is C. C. Parmelee. To the left of the arch, from left to right, are Aunt Lizzie Judson, her husband, V. Judson, and their daughter Vera Judson. (OBHS.)

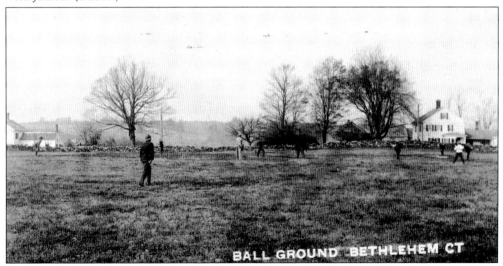

Eliza Ferriday, wife of Henry Ferriday, allowed the town to use the north end of the Bellamy Preserve on the corner of Munger Lane and Bellamy Lane as a baseball field. This may have been the first home of the Bethlehem Ploughboys. The house on the right is Joseph Stevens's and on the left is Phyllis and Walter Short's. Both houses are still there. (OBHS.)

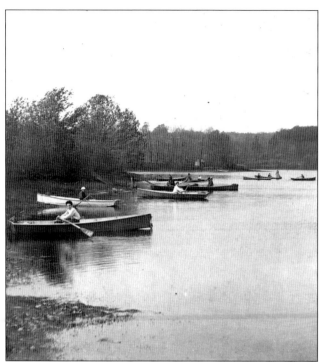

Long Meadow Pond is seen here at the dawn of the 20th century. (OBHS.)

Kasson Grove is situated on the east side of Long Meadow Pond. The families that owned the waterfront property in the grove in the mid-1800s were the Kassons, Browns, Munsons,

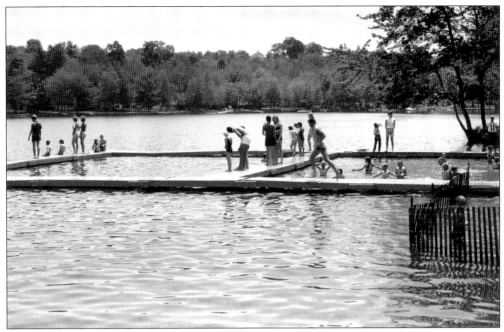

Swimming lessons were offered every summer at Long Meadow Pond by the Red Cross. (Edna Miller.)

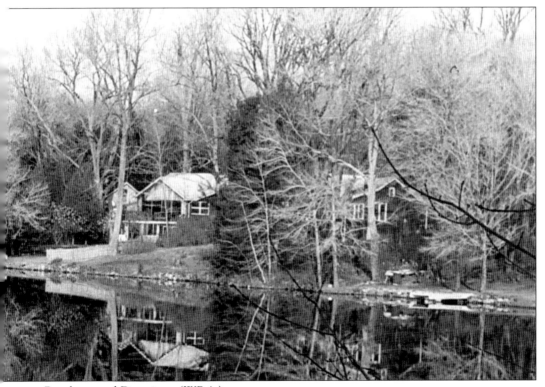

Beechers, and Dunnings. (WRA.)

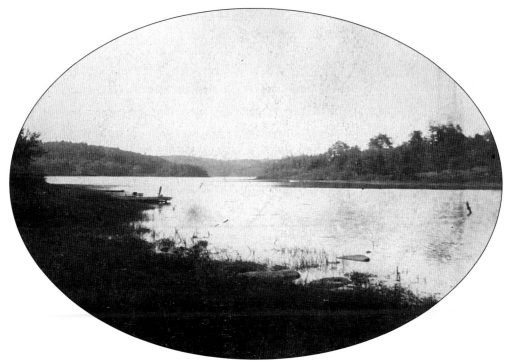

Long Meadow Pond was photographed in 1909. (Christine Thomson Bloss.)

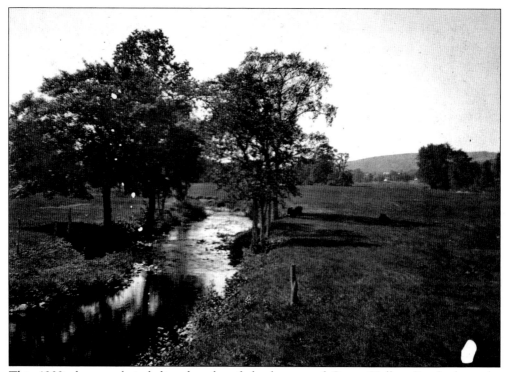

This 1909 photograph is believed to be of the bottom of Crane Hollow Road where the Weekeepeemee River crosses it. (Christine Thomson Bloss.)

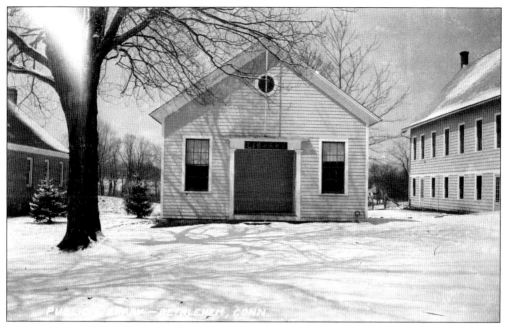

The District 1 schoolhouse closed in 1923 when the state declared one-room schoolhouses health hazards for lack of indoor plumbing. It served as the town's library until 1968, when the new library was built. It was used for Sunday school and storage by Christ Episcopal Church until the Old Bethlem Historical Society restored it as a living museum in 1991. (OBHS.)

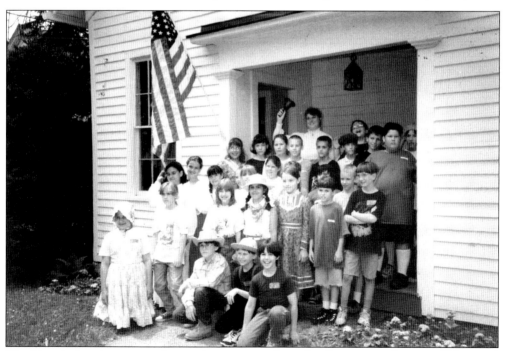

The historical society received special recognition from the Connecticut League of Historical Societies for its restoration of the District 1 schoolhouse. This 1996 photograph shows Michelle Margaitis and her fourth graders re-creating a school day in the 1850s. (OBHS.)

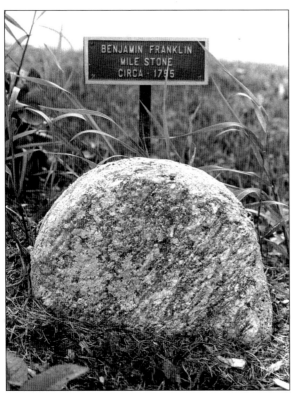

Benjamin Franklin became postmaster general of the colonies in 1753 and began to measure the distances along postal routes. With one of his children, he reportedly measured the distance to Litchfield along Route 6 and from Route 6 up Flanders Road. (WRA.)

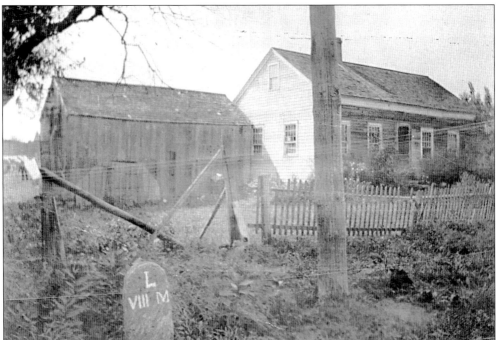

The two-foot-by-one-foot stone markers with the letters *L* for Litchfield, *M* for mile, and the Roman numeral *VIII* in front of the Painted Pony Restaurant tells the rider eight more miles to go to Litchfield. The nine-mile (IX) marker is seen at 160 Flanders Road. (OBHS.)

The Bethlehem Post Office in December 1951 was attached to Johnson's IGA store on Main Street North. (WRA.)

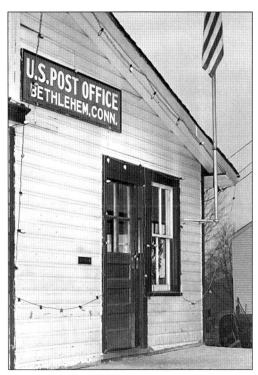

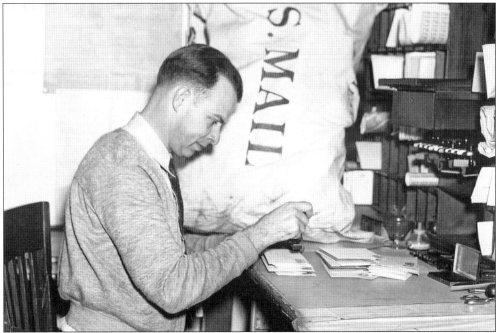

Earl Johnson was appointed postmaster in 1933 and served until 1974. In 1938, he had an idea that made Bethlehem "the Christmas town." He designed a rubber stamp imprinted with the simple outline of a Christmas tree and put it on every piece of mail. Even president-elect Franklin D. Roosevelt once had his mail stamped here. Every year since, local artists have submitted drawings for the annual cachet. (WRA.)

The town office building was constructed on the foundation of the Methodist church. It housed the fire department and the state police in the basement and the tax collector and town clerk on the first floor. It was designed by George Hatch and completed in 1941. (WRA.)

The town sold its old office building to the Old Bethlem Historical Society in 1976. The renovation of the building was supervised by president Doris Black Nicholls, who is seen going up to the front door. (WRA.)

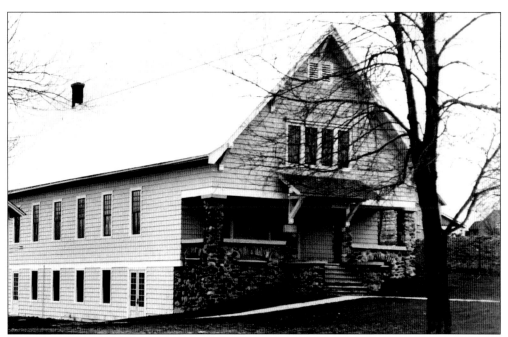

Old memorial hall was built in 1912 with materials and labor furnished by townspeople. Part of the lumber came from J. T. Parmelee's woods, south of the farm buildings. For many days, he furnished a team of horses and a hired man to draw stones for the foundation, according to his son Earle's scrapbook. Edward Crane supervised the building project in 1912. (WRA.)

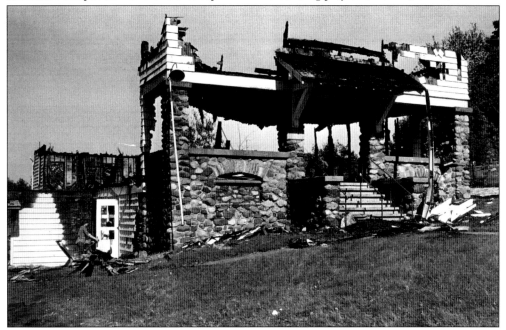

Only the stone porch remained on June 6, 1980, after a fire the night before destroyed the historic structure. "The emotional and nostalgic impact of the loss led to the overwhelming public approval of plans to replace the building," according to local Waterbury *Republican-American* newspaper reporter Paul Johnson. (WRA.)

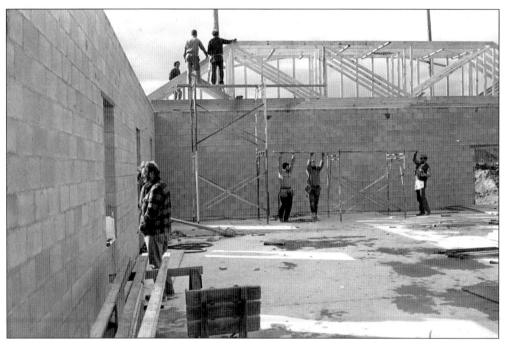

Building the new hall began immediately with volunteer labor and donations of money and services by townspeople. Here the crew tries to get a roof on before winter. (WRA.)

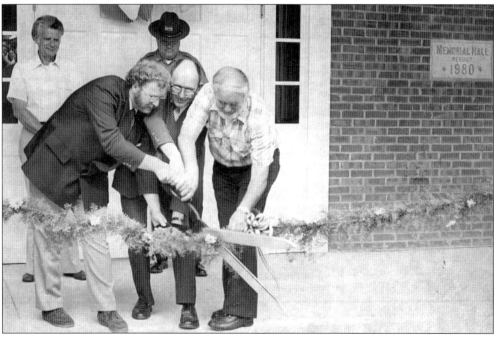

Ribbon cutting at the entrance of the new hall took place on July 4, 1981, thanks to a monumental effort by the town's citizens. Pictured cutting the ribbon from left to right are selectmen Leonard Assard, Sheldon Smith, and Emil Detlefsen. In the background are Patsy Narciso (left) and resident state policeman Pete Kaminski (right). Doris Black Nicholls was chairwoman of ceremonies for the festivities. (WRA.)

Seven

ORGANIZATIONS

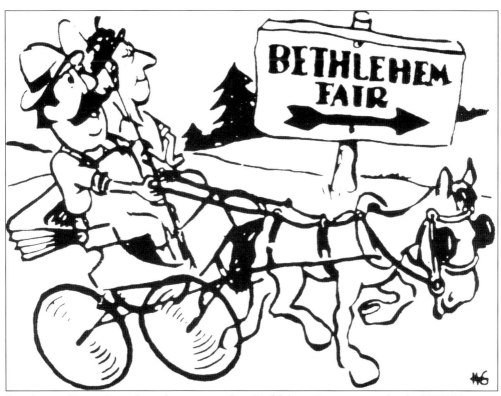

Local artist Henry Gros drew this cartoon for a Bethlehem Fair premium book. (OBHS.)

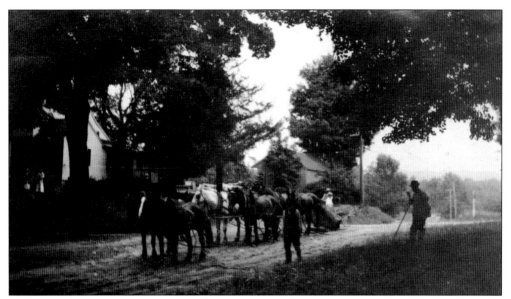

The horses in this photograph are pulling a stone sled to the green from Eliza Ferriday's land. She donated large stones on which to put the plaques honoring those who served in all the wars. (OBHS.)

The green is shown as it looked in 1919, when the stones were put in place. (OBHS.)

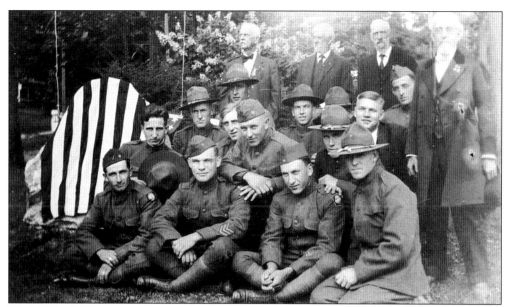

World War I veterans are seen at the dedication of the memorial stones on the green in 1919. Only the following are identified: William R. Smith (first row, far right), Burras Traub (second row, far left), Stanley Marchukaitis (third row, second from right), and Arthur Bloss (third row, far right). The four older gentlemen standing in the back are presumed to be the remaining Civil War veterans. (OBHS.)

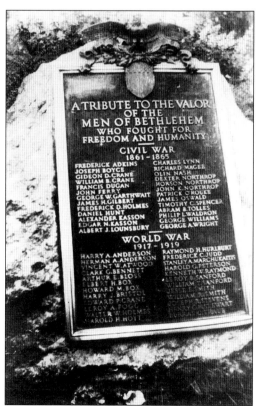

A plaque on one of the stones lists the Civil War and the World War I veterans. Another stone lists the Revolutionary War dead. More wars have been added, and these stones have been replaced. (OBHS.)

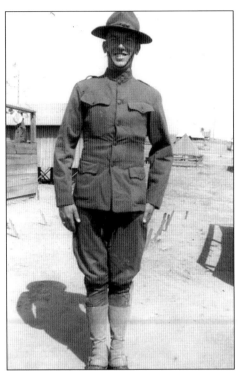

Arthur Bloss is pictured in his World War I uniform. The son of Dora and Nathan Bloss, he was also the first chief of the Bethlehem Volunteer Fire Department. (OBHS.)

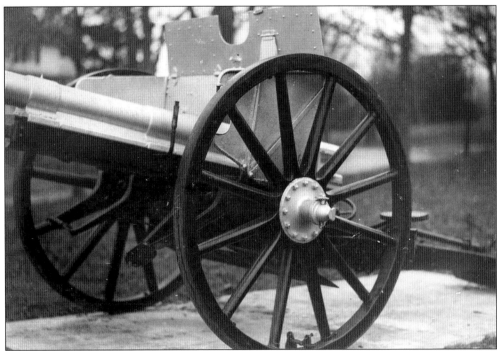

At their annual meeting on October 6, 1942, town of Bethlehem residents voted at the suggestion of Elliott Barnes to donate this World War I cannon as scrap metal to the war effort. They hoped it would hasten the defeat of the Axis and that they would be able to replace it with a new one captured from the enemy during World War II. (WRA.)

The Community Club, formerly the Girls Social Club, is on a road trip to Hyde Park. From left to right are Marie Stevens, Margaret Glover, Doris Cote, Sylvia Minor, Michelle Minor, Edney Hunt, Gertrude Huber, Olga Reichenbach, Lillian Traub, and Dorothy Anderson. (OBHS.)

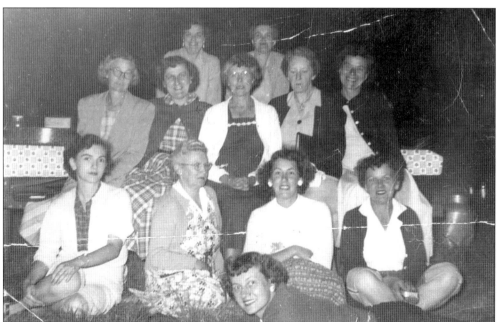

This is an undated photograph of the Community Club, and it shows the ladies at a picnic. (OBHS.)

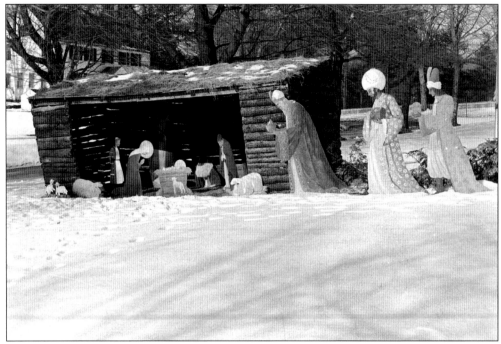

The original outdoor crèche on the green was painted on flat boards by Washington, Connecticut, artist Kent Witherill in 1952. The Grange and the Bethlehem Community Christmas Committee, under the supervision of Sara Brown and Mrs. H. B. Risley Sr., were in charge of raising the money. Sheldon Brown erected the stable. (Edna Miller.)

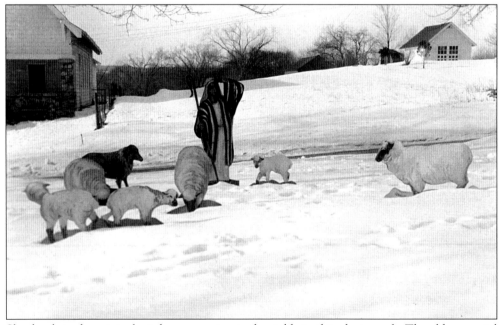

Shepherds in the original crèche are coming to the stable in this photograph. The old memorial hall is in the background. (Edna Miller.)

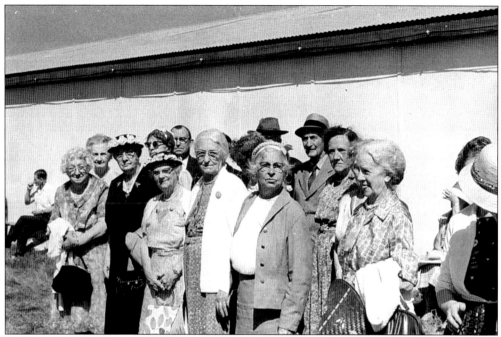

The members of the Bethlehem Grange who started the Bethlehem Fair gather at the first permanent exhibition building. From left to right are (first row) Agnes Johnson, Manie Johnson, May Allen Johnson, Lucy Tracy, Ruby Whittlesey, Ina Lake, and Hattie Hill; (second row) Belle Platt, Sarah Flowers, John Platt, Edna Lake, Zenas Candee, and Harry Johnson. (OBHS.)

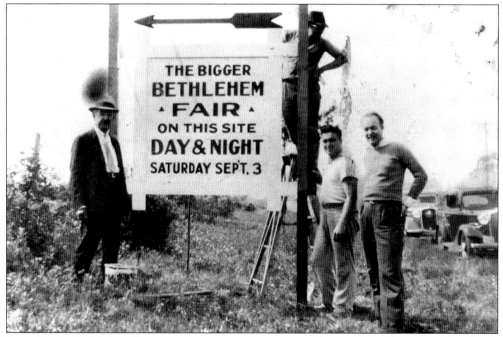

In 1946, the Bethlehem Fair moved to its new location on Route 61 North on Benedict family land. In the photograph from left to right are John Morissey, unidentified, Milt Grabow, and Paul Johnson. (OBHS.)

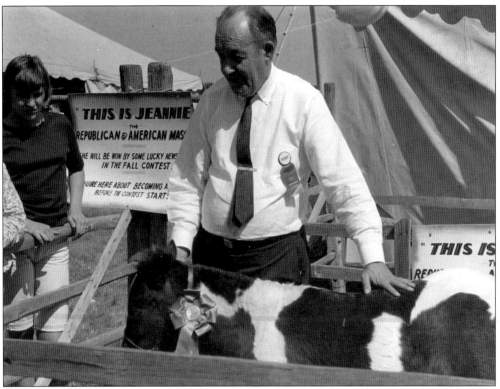

Paul Johnson is shown at the Bethlehem Fair in 1988. He was president of the fair for 59 years. He was also the reporter for the Waterbury *Republican* and *American* for many years. Here he pats Jeannie, the paper's mascot. (Edna Miller.)

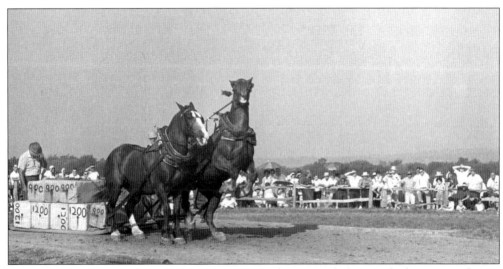

Every year, the horse-pulling competition attracts a large crowd along with the pony and oxen draws. The Bethlehem Fair retains its rural agricultural country flavor to this day. (Edna Miller.)

Everyone lends a hand on fair weekend. From left to right, Pat Butler, Larry Ganung, and John Botelle get the many signs ready to put out on the grounds. (WRA.)

Fair office manager Bernie Law (left) consults with fair president Elaine Assard Brodeur (right). There have only been four fair presidents in its 85-year history: Paul Johnson; his wife, Ann Butler Johnson; Sam Swendsen; and, as of 1995, Brodeur. (WRA.)

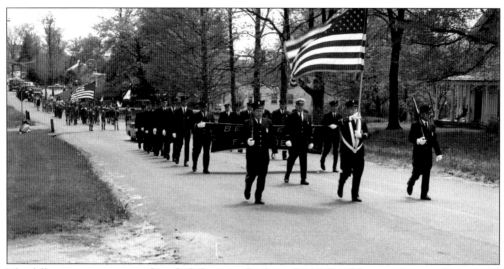

The following pages are unidentified photographs from the 1960s of the town's annual Memorial Day parade, which still looks the same today. The volunteer firemen parade from the intersection of Flanders Road and Main Street South to the green. Herb Goodwin (left) and Bob Overton (far right) are the riflemen. Note the Gulf gasoline station down Main Street. (Edna Miller.)

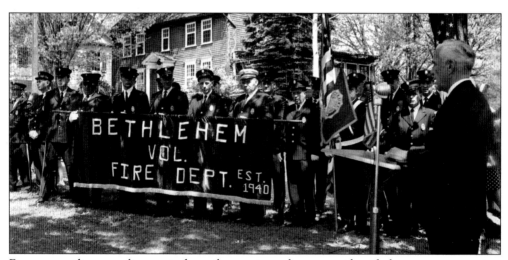

Firemen on the green line up to hear the guest speaker, an unidentified state representative. Bob Overton is to the left of the speaker. In line holding the banner from left to right are James Assard, John Kalukaitis, unidentified, John Osuch, unidentified, Fred Piersall, John Rudzavice, Emil Detlefsen, and Herb Goodwin. (Edna Miller.)

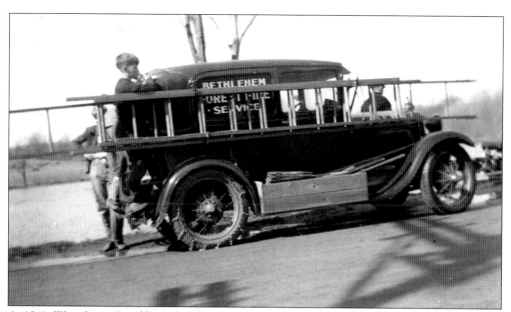

A 1941 Waterbury *Republican* headline reads as follows: "Bethlehem Gets Up-to-Date Fire Engine." The caption with the photographs said that "Bethlehem now boasts a new $3,800 fire engine [below] . . . The old vehicle [above] will be kept for forest fire work under Warden Earl Johnson. It has a portable pump." In 1941, both engines were housed in the basement of the new town hall, now the Old Bethlem Historical Society museum. Arthur Bloss was fire chief and Dwight Bennett was assistant fire chief. (OBHS.)

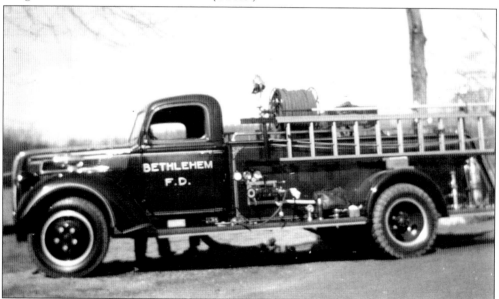

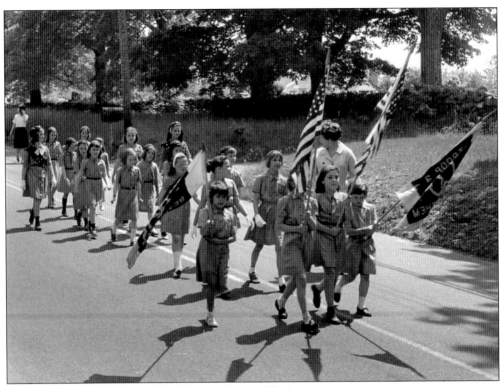

The Brownies parade down Main Street. (Edna Miller.)

The Girl Scouts created a float to ride down Main Street. (Edna Miller.)

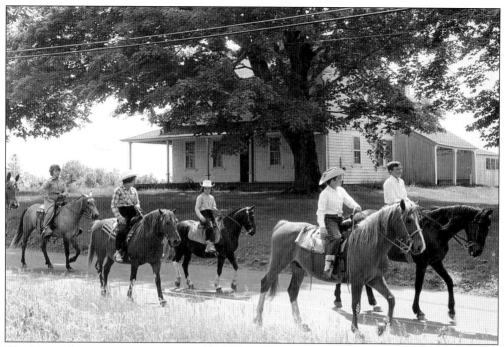

The Junior Committee was a group of boys that was responsible for the first Bethlehem Horse Show, which was held on Ferriday Field in back of Eliza Ferriday's house in 1933. The proceeds went to the library for books during the Depression. These riders perhaps are a spin-off from the earlier group. The boy on the left is Frank DiBiase. The boy in the back right is identified as Jimmy March riding John Ray Osuch's horse Lindy. (Edna Miller.)

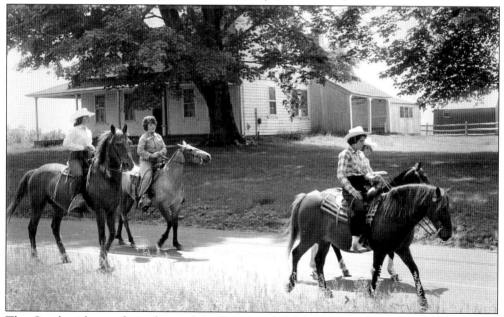

The Osuch girls parade in front of the house at 122 Main Street South. From left to right are Georgina Panulaitis, Eloise Osuch, Janice Osuch Poole, and Betta Osuch Rabideau. (Edna Miller.)

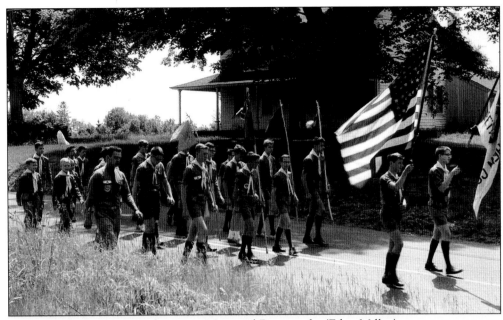

Boy Scouts have participated in every Memorial Day parade. (Edna Miller.)

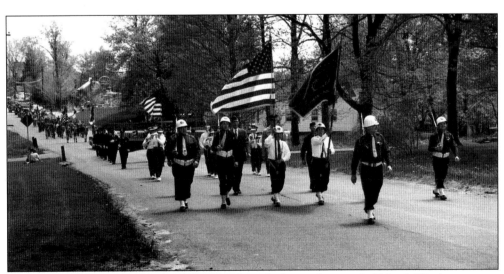

Veterans always lead the Memorial Day parade with their color guard. (Edna Miller.)

Eight

IMMIGRANTS

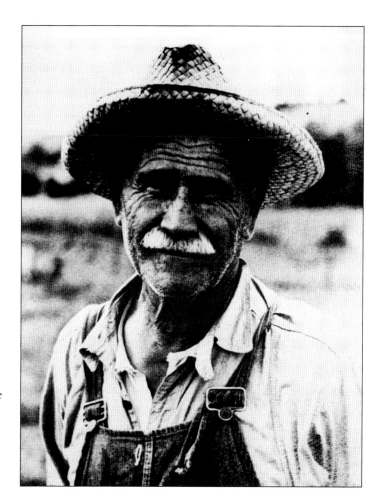

The arrival of the Lithuanian and Lebanese immigrants in the early 1900s changed the face and the future of the town. Pictured here is Bou-Akl Tanuis. (Akle Tanuis.)

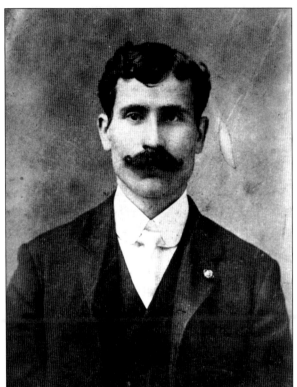

In the early 1900s, young Bou-Akl Tanuis came from Knaisset-el-Meuttoh, Lebanon, then part of Syria. First he went to Danbury, where he married his wife, Mohaby. (Akle Tanuis.)

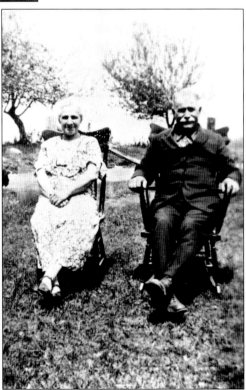

Bou-Akl Tanuis and his wife, Mohaby (Slaiby) Tanuis, are sitting outside their Todd Hill Road farm in 1970. (Akle Tanuis.)

Shaker Assard bought a farm on Wood Creek Road close to the Washington, Connecticut, line and was photographed soon after arriving. From left to right are (first row) Assard holding his son George and Mary Slaiby Assard holding their son Joseph; (second row) Mary's sister Mohaby Slaiby and Peter Assard. (Martha Buzaid O'Keefe.)

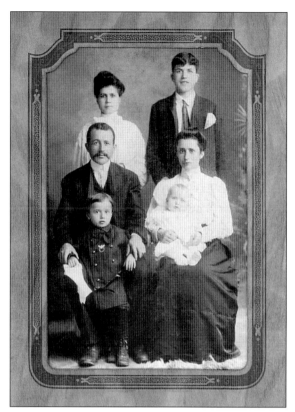

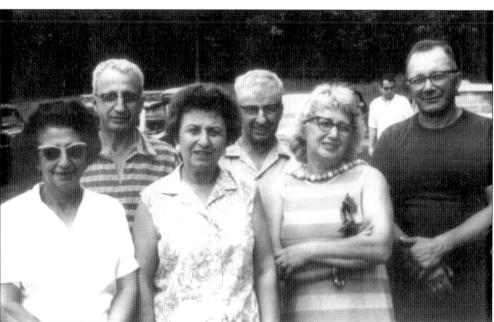

Pictured from left to right are Shaker and Mary Slaiby Assard's grown children Nellie Carlson, George Assard, Lena Knibloe, Joseph Assard, Hannah Martin, and James Assard. (Martha Buzaid O'Keefe.)

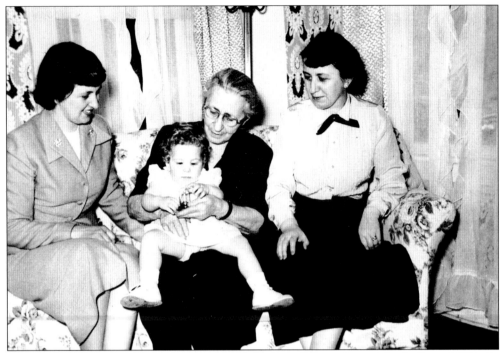

Four generations of Assard women are pictured here. From left to right are Martha Buzaid O'Keefe, Patricia O'Keefe, Mary Slaiby Assard, and Lena Assard Buzaid. (Martha Buzaid O'Keefe.)

James Assard's family are descendants of Shaker Assard and have been active in the Bethlehem community. From left to right are (first row) Elaine Assard Brodeur and Kathy Assard Bixby; (second row) James Assard, Leonard Assard, Bernice Johnson Assard, and Eileen Assard LeClerc. (Bernice Assard.)

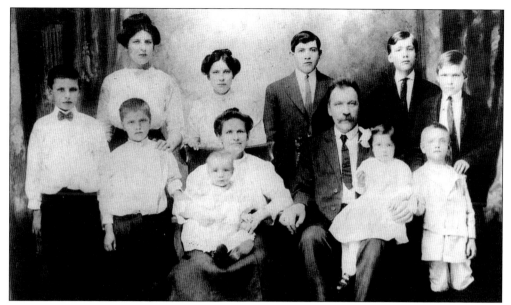

Rose and Thomas Marchukaitis and their nine children immigrated to the United States from Lithuania in 1912. They moved from Waterbury to Bethlehem in 1915, purchasing the 114-acre Nathan Bloss farm on Munger Lane (March Farms). They worked the farm, and Rose served as a midwife, delivering many of the neighbors' babies. Pictured from left to right are (first row) Joseph, John, Matthew, Rose, Thomas, Eva, and Bartholmew; (second row) Anna, Magdalena, Magdalena's husband Joseph Lizauskas, Peter, and Stanley. (Barbara Plungis Shupenis.)

All nine Marchukaitis children are pictured in this 1973 photograph. From left to right are (first row) Eva, Magdalena Lizauskas, and Anna Kacerguis; (second row) Peter, Stanley, Joseph, John, Bartholmew, and Matthew. (Barbara Plungis Shupenis)

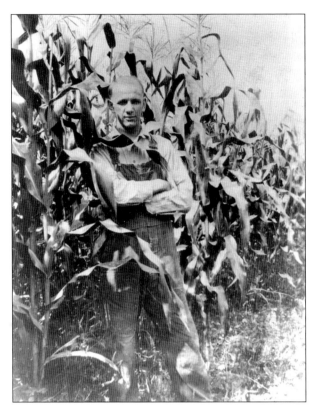

The first Lithuanian family to settle in Bethlehem was the Peter Butkus family in 1909, purchasing a farm on Hard Hill Road. Peter's son Bruno (left, at age 19) was the first Lithuanian to hold office in Bethlehem, serving as town auditor and on the board of selectmen in 1944. (Walter Hunt.)

Russ Peterson's horse-drawn wagon carried the coffin of Bruno Butkus from the Church of the Nativity to Bethlehem's Evergreen Cemetery in 1978. The wagon was flanked by an honor guard of volunteer firemen. (WRA.)

Nine

ARTISTS

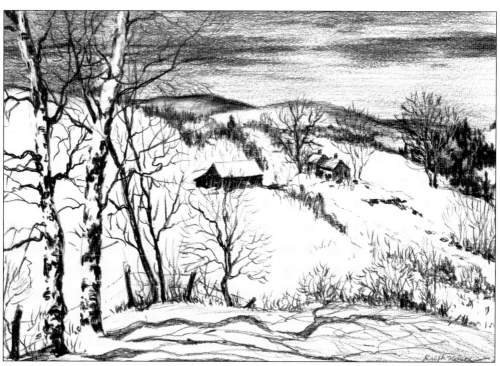

The peace and beauty of the Bethlehem countryside was conducive to the creative soul of the artist Ralph Nelson. This is his sketch titled *Winter in Bethlehem*. (Matang Gonzales.)

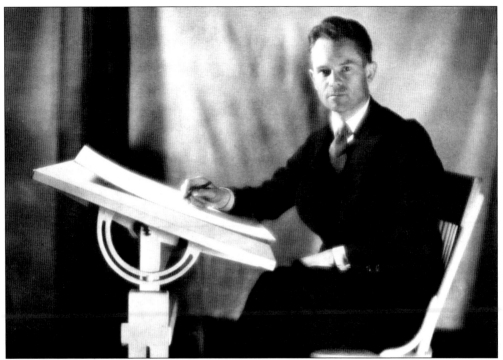

Ralph Nelson (1885–1967) came to Bethlehem in 1939. His early professional work was sketching important events for newspapers, magazine illustrations, and book jackets. During the Depression, he did murals and paintings for the Works Progress Administration. He is best known in Bethlehem for his paintings of old houses, winter scenes, and Christmas cards. The photograph below shows his studio on Guild Hollow Road, formerly the Glosky Blacksmith Shop. (Matang Gonzales.)

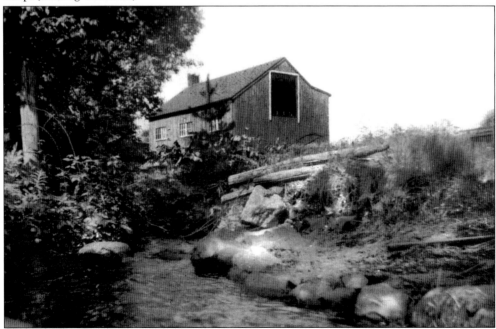

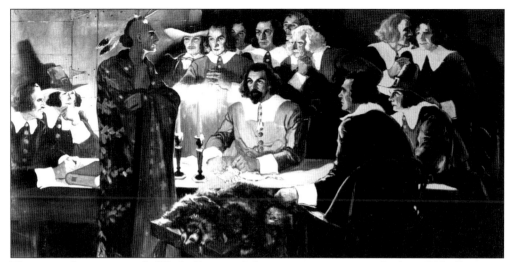

These murals were part of a Works Progress Administration project in the late 1930s. Five were pasted on the walls of the library at the old East Hartford High School (now Center School). A sixth mural is in the Silver Lane School in East Hartford. (Vincent Bove.)

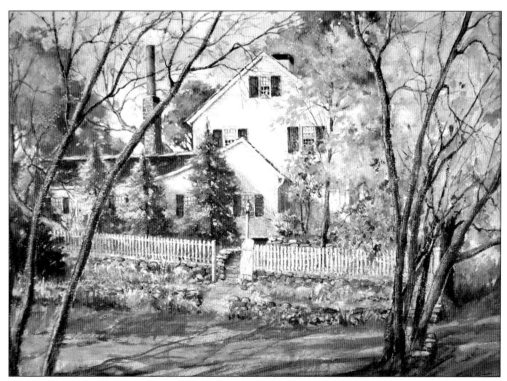

Pictured above is Nelson's painting of the Crane house at the intersection of Guilds Hollow Road (Route 132) and Weekeepeemee Road. (Doris Black Nicholls.)

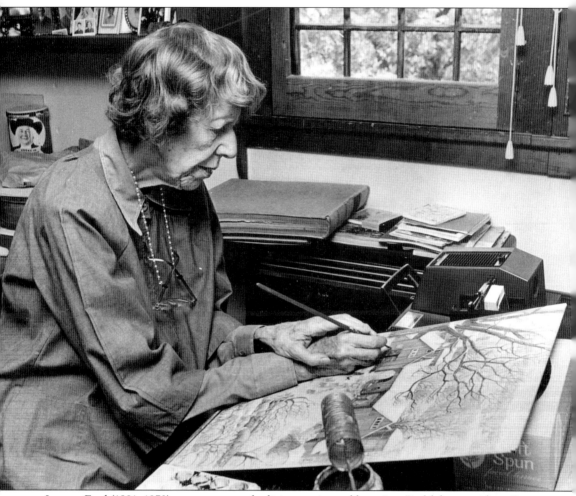

Lauren Ford (1891–1973) was a renowned religious artist and longtime Bethlehem resident. Born and raised in Rye, New York, Ford lived in France for a time, painting and studying ecclesiastic art and chant. She converted to Catholicism in 1929. The subject of her work after this was religious painting, namely the Nativity and the holy family. Her work has been shown in prestigious galleries and in the collections of many museums. She is well known for her religious Christmas cards. (Antoinette Keilty.)

Antoinette (Toni) Keilty was Ford's friend and worked for her from 1942 until Ford died in 1973. (Antoinette Keilty.)

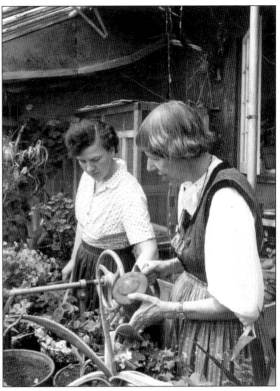

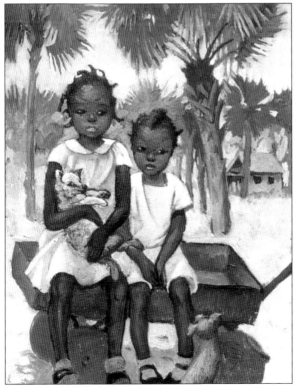

While vacationing on Sanibel Island in Florida, Ford showed her skill as a portrait artist as well as capturing the tropical landscape. (Antoinette Keilty.)

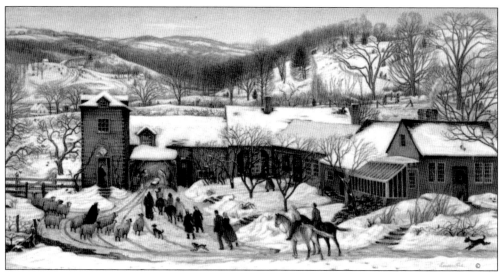

In 1933, Lauren Ford purchased her farm named Sheepfold, located in Crane Hollow. When asked why, she said, "Bethlehem is like a sheepfold. The hills seem to fold in protectively around it." Her home was depicted in her paintings of the nativity. The tower on the left was built by local Lithuanian neighbor Walter Duda. (American Artists Cards, New York.)

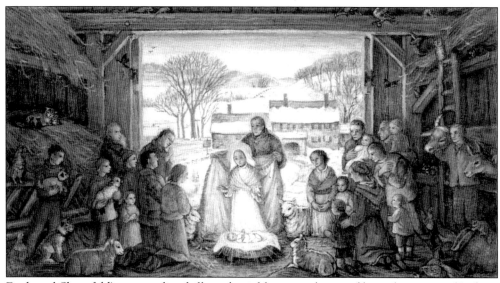

Ford used Sheepfold's surrounding hills and neighbors as subjects of her religious art. (Barbara Plungis Shupenis.)

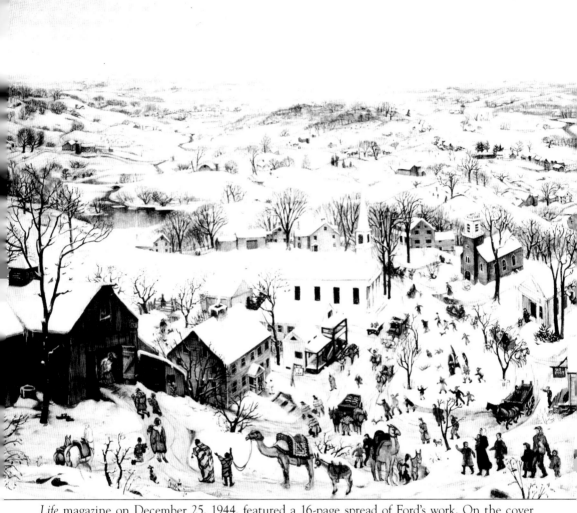

Life magazine on December 25, 1944, featured a 16-page spread of Ford's work. On the cover was her *Madonna and Child*, the only color cover of *Life* during World War II. The centerfold featured this painting of her beloved village described as follows: "In Ford's oil painting *Epiphany in Bethlehem*, the three wise men that 'followed the star' are depicted in her own hometown. The caravan, complete with camels and a donkey, has come down snow-covered Main Street and are approaching the barn where the Christ child lay. One of the king's retinue is looking for lodging at the inn, while another stops at Minor's General Store and he emerges with a bag of goodies in his hand. Ford's village neighbors hurry to the scene and stare in amazement at the sight." (Indianapolis Museum of Art, the Delavan Smith Fund.)

Henry Gros was both an artist and an inventor. He holds a patent on a mooring device for dirigibles. He attended the Rhode Island School of Design, and after retiring from the Waterbury Tool Division of Vickers, he became a cartoonist for the *Sunday Republican* newspaper. (WRA.)

Gros designed this cachet for the Bethlehem Post Office and for a cover on a town report. He also designed Christmas cards. (OBHS.)

"THE CHRISTMAS TOWN"
BETHLEHEM, CONN.

Gros captured the moment in 1971 when the number of people finally outnumbered the number of cows. In the early 1900s, there were 17 dairy farms supplying milk mostly to the city of Waterbury. (WRA.)

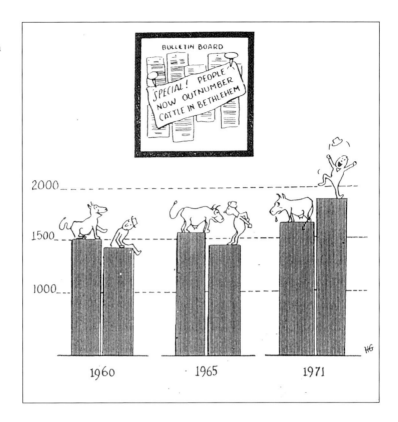

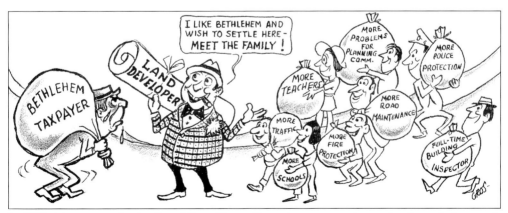

In 1973, his cartoon for the Republican Town Committee supporting a plan for orderly growth was a warning about land developers. (OBHS.)

Bethlehem resident Edna S. Miller (1917–1997) was a well-known photographer whose works were published by Connecticut Light and Power and also *Yankee* magazine. (Edna Miller.)

Miller captured the beauty of Bethlehem's landscape and seasonal changes, documenting the town's celebrations and parades. (Edna Miller.)

Ten

PEOPLE

Mattie Doolittle is pictured here in 1875 at age 20, the daughter of David E. and Mary Jane (Taylor) Doolittle. The Doolittles lived in the area of Carmel Hill North and Wood Creek Road near Wood Creek Pond, later called Zeigler's Pond. (OBHS.)

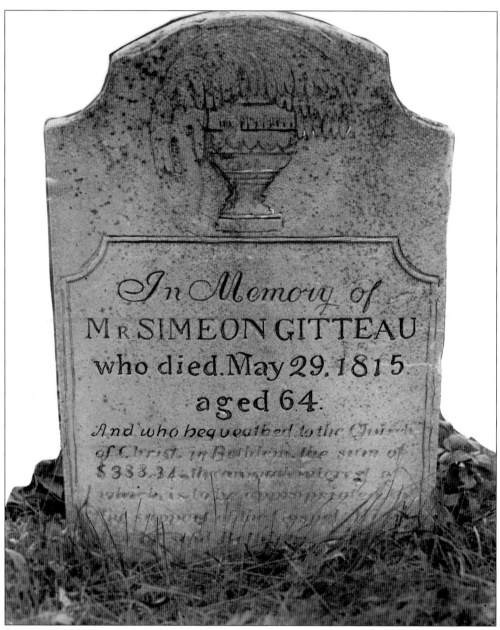

In Memory of
Mr SIMEON GITTEAU
who died. May 29. 1815
aged 64.
And who bequeathed to the Church
of Christ. in Bethlem. the sum of
$333.34.

Simeon Gitteau's tombstone in the old burial ground on Bellamy Lane notes that when he died in 1815, he bequeathed Christ Episcopal Church $333.34. Joshua Gitteau was one of the early settlers to come to Bethlehem. His grandson Charles Julius Gitteau became famous when he assassinated Pres. James A. Garfield in 1881 and was later hanged for his crime. (WRA.)

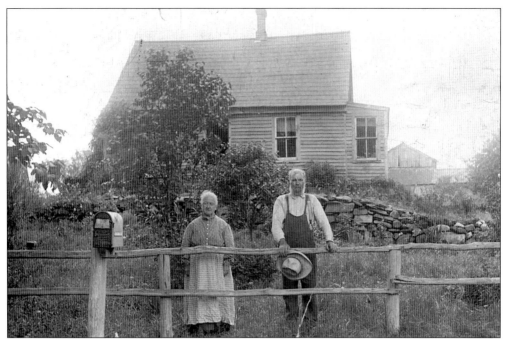

Judge Charles Wiltshire (1847–1935) and his wife, Sarah J. Wiltshire (1841–1924), stand in front of their home at 27 Judge Lane. Justice of the peace Arnold E. Smith built a new house on the foundation of the Wiltshire home. (OBHS.)

Henry Hubbard was born in Morris in 1840. After the Civil War, he settled in Bethlehem on a 70-acre farm on North Main Street near the Beardsley property, which is now Kasson Grove. Hubbard's land ran down to Long Meadow Pond, and in his later years when he was blind, he rented out boats and allowed camping on his lake property. (OBHS.)

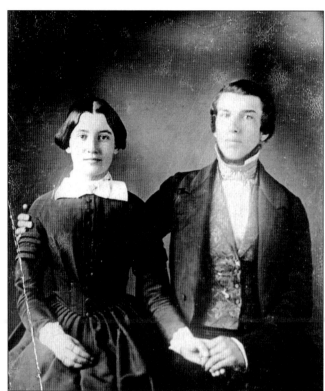

Charles and Nancy (Lambert) Bloss are pictured after they were married. They were Nathan Bloss's parents, Walter Bloss and Arthur Bloss's grandparents, and Betty Bloss's great-grandparents. (Betty Bloss Barbour.)

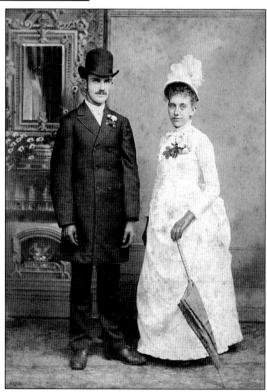

Nathan and Dora Bloss are pictured on their wedding day. (Betty Bloss Barbour.)

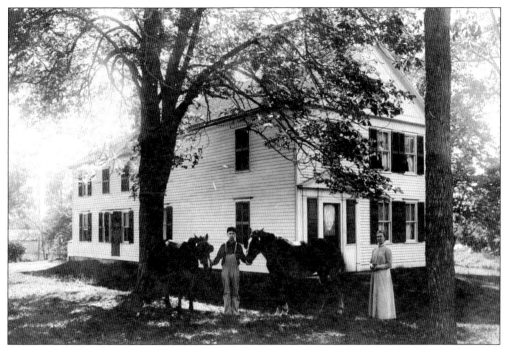

Here is the Bloss home at 18 East Street, with Arthur Bloss and Dora Hill Bloss (1868–1951) in the front yard. She was an active Grange member for over 60 years and a founder of the Bethlehem Fair, which began as a Grange activity in memorial hall. (Betty Bloss Barbour.)

Betty Bloss was the daughter of Walter F. and Marjorie (Atwood) Bloss. She married her neighbor Ron Barbour and moved to Florida in 1946. (Betty Bloss Barbour.)

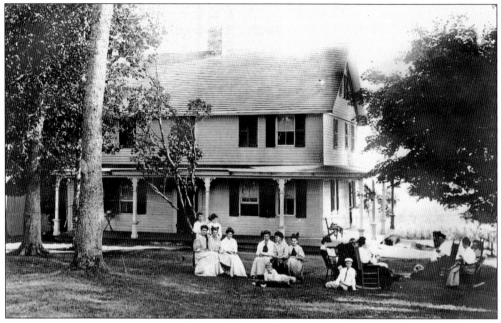

Fairview Farm was the name of the Thomson family's home. It was located at the end of Thomson Road, which used to go through Guilds Hollow over Mill Pond Road, connecting with Arch Bridge Road (then called Addie Griswold Road), across Carmel Hill Road, through Arrowhead Farm, and into Washington, Connecticut. (OBHS.)

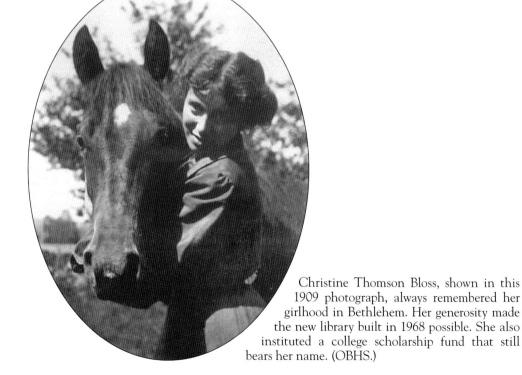

Christine Thomson Bloss, shown in this 1909 photograph, always remembered her girlhood in Bethlehem. Her generosity made the new library built in 1968 possible. She also instituted a college scholarship fund that still bears her name. (OBHS.)

Pictured is Christine's father, Frederick Thomson, in 1909. (OBHS.)

Christine's mother, Minnie E. Thomson, in 1909, is shown "salting the butter." (OBHS.)

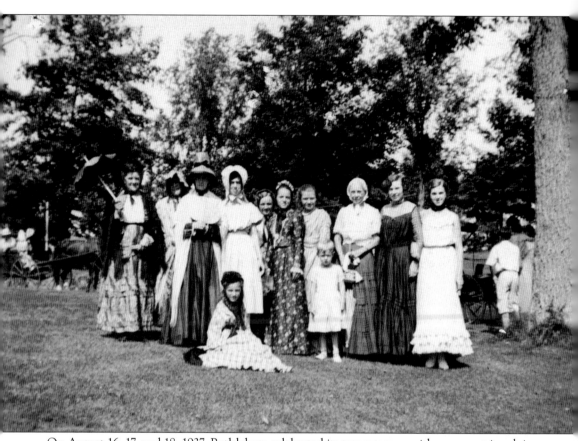

On August 16, 17, and 18, 1937, Bethlehem celebrated its tercentenary with a pageant involving a majority of townspeople, horses, and carriages. The episodes of the pageant included the purchase from Native Americans, the plague of 1750, Rev. Joseph Bellamy, becoming a town, early home life, and tavern scenes. Ladies of the tercentenary are pictured in costume on the green in 1937. Seated in front is Eleanor Lowenthal. Standing, from left to right, are unidentified, unidentified, Manie Johnson, Marion Johnson, Minnabel Smith, Virginia Smith, unidentified, unidentified, Ada Benedict, Mabel Waldron, and Vivian Rand. (OBHS.)

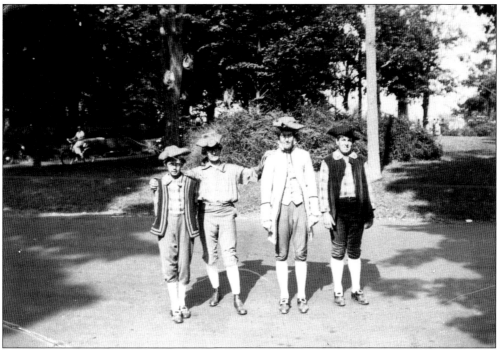

Players in the tercentenary pageant appear in costume. Only Allan Woodward on the left is identified. (OBHS.)

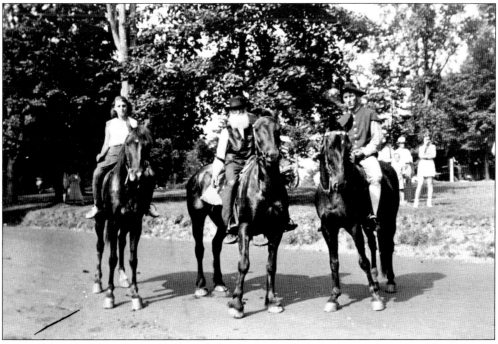

Pictured from left to right are unidentified, Charles Hunt, and John Roden. Roden had parts in all episodes of the pageant, including as Deacon Hooker in the plague of 1750 and as Jonathan Munger in the first Sunday school in 1767. (OBHS.)

Truman and Margaret Minor are pictured in 1914 with their daughter Edith, who taught school at the Minortown School in Woodbury. Ames Minor was their grandson. (Michelle Minor.)

Viola and Ames Minor are pictured as children. They lived at 110 Main Street South with their parents Arthur T. and Mary Ames Minor. Ames was a decorated World War II hero and later first selectman in town. (Michelle Minor.)

Frederick Allen lived at Eastover Farm located on Guilds Hollow Road (Route 132). It was built in 1773 by the Allyn family who were from England. Dr. Frederick W. Pratt purchased it in 1929, and his family still owns the property. (OBHS.)

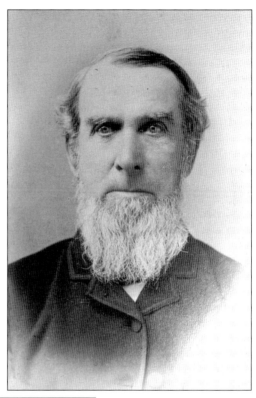

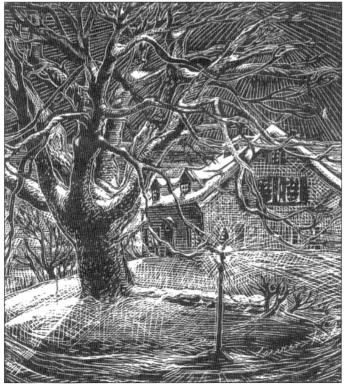

This scratch painting of Eastover Farm by local artist Lauren Ford was done for the Pratt family as their Christmas card. (Mary Hawvermale.)

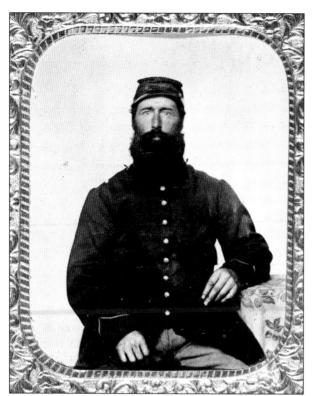

Civil War soldier James Benedict is photographed as a young man. (Clara Benedict.)

As a senior citizen, Benedict lived at 198 Hard Hill Road North. He was fond of growing flowers. (Clara Benedict.)

Thirza Cornelia (Dibble) Benedict was the mother of the seven Benedict men pictured below. (FCB.)

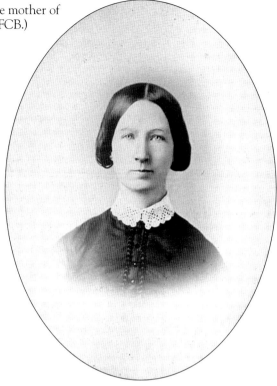

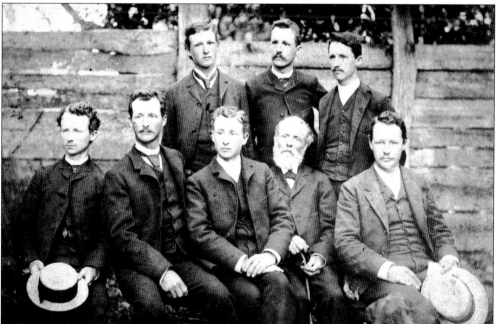

This is a photograph of James Benedict and his sons by Thirza. From left to right are (first row) Roswell (attorney and musician), Edgar (farmer), Samuel (businessman), James (father), and James Jr. (head of the Smithsonian); (second row) Henry (died at age 19), Neal (New York businessman), and Lorenzo (New Jersey banker). (Clara Benedict.)

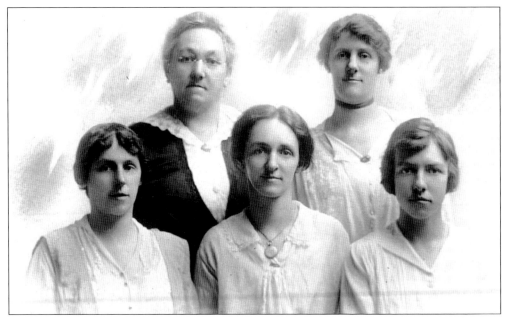

Emma Jane (Black) Smith is pictured with her daughters. From left to right are (first row) Emma Smith Risley, Lucy Smith Tracy, and Myra Smith Hurlburt; (second row) Emma Jane and Phoebe Smith. Emma and her husband, Jesse E., were married for more than 50 years. They met when he worked at a creamery in Washington, Connecticut. She is a Gunn descendant from the same family that founded the Gunnery School in Washington. (Virginia Smith Dodd.)

Jesse E. Smith was a well-respected dairy farmer and owner of the White Clover Creamery. A native of North Carolina, he had three sons. From left to right are (first row) Jesse W. Smith and William Reed Smith Sr; (second row) Jesse E. Smith and Herbert Smith. (Virginia Smith Dodd.)

Sophia Stillson was the grandmother of May Allen Johnson. The Stillsons lived on Carmel Hill Road. (OBHS.)

Mary (Stillson) Crane Allen, born about 1848, was May Allen Johnson's mother. She lived at 120 Crane Hollow Road after her marriage to Samuel Allen. (OBHS.)

Mary Carpenter Flynn (left) and Edith Lake go for a spin. (Mary Woodward.)

Ina Lake (left) and Dora Glosky, the blacksmith's daughter, show off their new bicycle. (OBHS.)

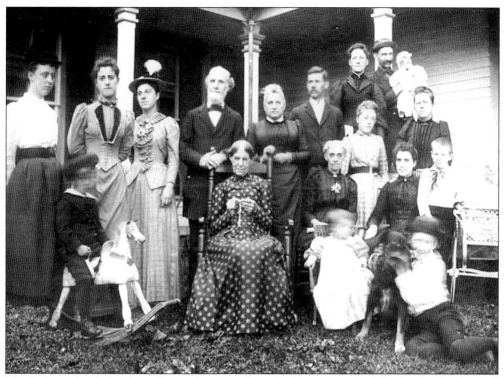

The Jackson family lived in a house that was where the library is today. The family also donated the land for the first memorial hall. Later the Mason Hunt dairy farm, the house was moved down the street and later demolished. (OBHS.)

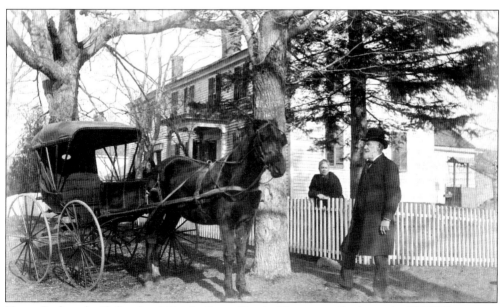

Henry Peck and wife lived at 56 Main Street South. He was a tailor by trade. (OBHS.)

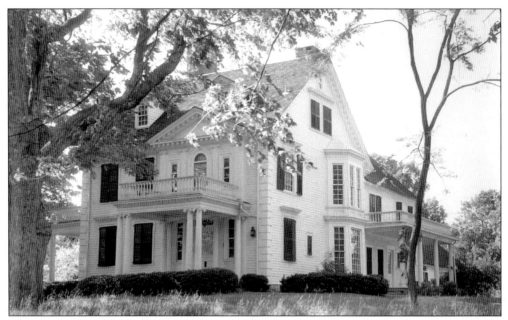

The Ferriday house looked like this when Caroline Woolsey Ferriday made it her summer home. In 1860, the Hull family made considerable changes in the main portion of the house. Henry McKeen Ferriday purchased the property in 1912. Known as "the Hay," the house and gardens were bequeathed to the Antiquarian and Landmarks Society in 1990. The Antiquarian and Landmarks Society is now known as Connecticut Landmarks. (Edna Miller.)

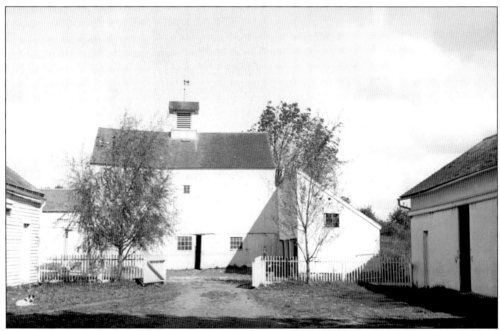

The outbuildings of the Bellamy-Ferriday house are pictured here in the early 1900s. Caroline Woolsey Ferriday donated the barn in the center to the Abbey of Regina Laudis in 1948 for its 1720 Neapolitan crèche. (Connecticut Landmarks.)

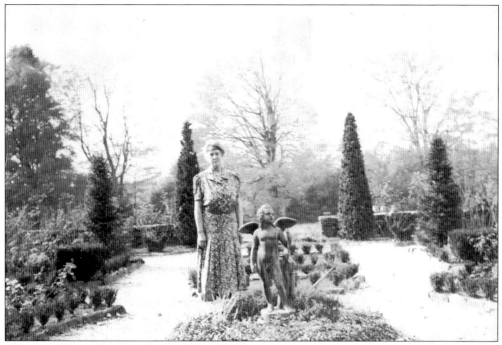

Eliza Ferriday is shown in her garden, which is now famous in Connecticut for its parterre plantings and antique lilacs. Her daughter Caroline specialized in roses, and the house has an extensive library of books on roses. (Connecticut Landmarks.)

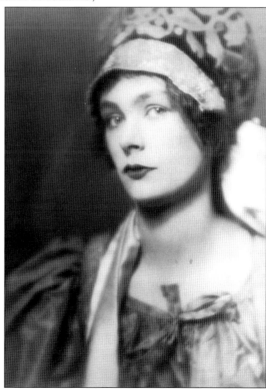

Caroline Woolsey Ferriday (1902–1990) was an actress, philanthropist, and humanitarian. After World War II, she aided the woman of Ravensbruck in Germany who had been used for Nazi medical experiments. (Connecticut Landmarks.)

ACROSS AMERICA, PEOPLE ARE DISCOVERING SOMETHING WONDERFUL. *THEIR HERITAGE.*

Arcadia Publishing is the leading local history publisher in the United States. With more than 3,000 titles in print and hundreds of new titles released every year, Arcadia has extensive specialized experience chronicling the history of communities and celebrating America's hidden stories, bringing to life the people, places, and events from the past. To discover the history of other communities across the nation, please visit:

www.arcadiapublishing.com

Customized search tools allow you to find regional history books about the town where you grew up, the cities where your friends and family live, the town where your parents met, or even that retirement spot you've been dreaming about.